IMAGES
of America

MANHATTANVILLE
OLD HEART OF WEST HARLEM

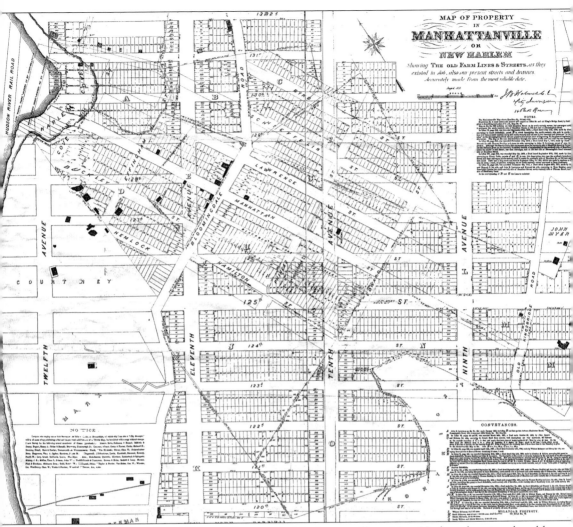

This 1878 map is labeled "Map of Property in Manhattanville or New Harlem showing the old Farm Lines and Streets, as they existed in 1806, also our present streets and Avenues." It is signed by J.B. Holmes, city surveyor. (David Dennis.)

IMAGES
of America

MANHATTANVILLE
OLD HEART OF WEST HARLEM

Eric K. Washington

ARCADIA

First printed in 2002.

Published by Arcadia Publishing,
an imprint of Tempus Publishing, Inc.
2A Cumberland Street
Charleston, SC 29401

Printed in Great Britain.

Library of Congress Catalog Card Number: 2001098518

For all general information contact Arcadia Publishing at:
Telephone 843-853-2070
Fax 843-853-0044
E-Mail sales@arcadiapublishing.com

For customer service and orders:
Toll-Free 1-888-313-2665

Visit us on the internet at http://www.arcadiapublishing.com

CONTENTS

ACKNOWLEDGMENTS

For resources and friendship extended to this project, I am indebted to Rev. Earl Kooperkamp, Gwendolyn Davis, Robert Jones, Janet Dorman, Liz and Allan Mellen, Pearl Harris, Erica Charles, and Rev. Robert Castle of St. Mary's Protestant Episcopal Church. I also wish to thank Fr. Jose M. Clavero and Christina Fidanque of the Church of the Annunciation, Paul Radensky and Paul Salazar of the Old Broadway Synagogue, and Heather Franz of the St. Joseph's Roman Catholic Church School.

I extend my gratitude to David L. Tiemann, Michael Hogan Styles, and William Devlin for their amiable and generous exchanges. I also thank David Dennis, Raymond Clinton, Aristedes Demetriou, Bill Solis, Marilyn Stultz, and John Heliker.

Much appreciation goes to the following: Brian Feeney; Katherine Hansen; John Daskalakis; Shelley Yates; Devra Zetlan; Bette Wenek; Wayne Kempton; Peter Rothenberg; Col. Michael J. Stenzel, New York Guard; Nancy Richards; Andrew Alpern; Ricardo Pla; David Hodgson; Michael Rizzo; Herbert Seignoret; Eugene Hyon; Ken Harlin; Miriam Rosen; Carolyn Kent; George Baker; John Gomez; Leon Yost; Michael Mowatt-Wynn; Sandy Levine; Cynthia Copeland; Grady Turner; Diana Wall; Stewart Desmond; Justin Ferate; Christopher Moore; Anthony Toussaint; Jim Huffman; George W. Goodwill; Maritta Dunn; Joseph Wolin; Susan Kastan; Ron at Old Paper Archives; Tom DeMott; Greg and Donna Dinkins; Anthony Bowman; Joan and Norman Levine; Barbara Duncan; E.R. Shipp; Carl MaultsBy; Claudine Allison; Yuien Chin; John Reddick; Joyce Hackett; Margaret A. Lamb and E. Fred Garel; Ronald Lee Melichar; Mark J. Schoofs; Walter and Patricia South; Sarah M. Martin; Michael J. Palma; Jordi Reyes-Montblanc; Diane DeVeaux; Eliott and Christine Kahn; Bill Goodhart; Isabella Smith; John and Cynthia Washington; and Steve Smith.

I extend my thanks to the Guides Association of New York City and to the helpful staffs of Columbia University Library, the New York Public Library (NYPL), the New-York Historical Society, the Municipal Research and Reference Library, and the Municipal Archives.

I am grateful to funding assistance with this book from the New York City Department of Cultural Affairs, C. Virginia Fields (Manhattan borough president), Stanley E. Michels (city councilmember), and Rejoicensemble.

INTRODUCTION

Situated on upper Manhattan's west side, Manhattanville was one of old New York's most important 19th-century villages. It shared a century of prominence opposite the village of Harlem but then fell into obscurity.

Manhattanville's historic record began two centuries before its founding. As far back as the early 17th century, the area was an obvious place to make inroads and to become the crossroads of an extensive transportation system. Its alluring beachlike cove, indenting upper Manhattan's steep western shoreline, may have persuaded Henry Hudson to linger. A journal of the explorer's voyage on the *Half Moon* records his presence there on September 13, 1609: "The tide being done we anchored. Then there came four canoes aboard, but we suffered none of them to come into our ship; they brought very great store of very good oysters aboard, which we bought for trifles." The encounter perhaps initiated the area's future role as a node of trade and transportation. Hudson's visit anticipated the first tide of non-native settlement to the area decades later.

In 1658, the Dutch village of Nieuw Haarlem was established across the island at present-day East 125th Street near the Harlem River. By a cross-island route, villagers were already regularly shepherding livestock to this outlying valley on Hudson's River, which they called Moertje David's Vly.

With the bloodless capture of Manhattan in 1664, the Dutch colony of New Amsterdam became the English colony of New York. Two years later, this same valley became the northern end of a land patent boundary that New York's English governor, Richard Nicolls, had conceived. The so-called Harlem Line began at 74th Street on the East River and stretched diagonally across the island to 129th Street at the Hudson River inlet, called Harlem Cove, where 140 years later Manhattanville appeared.

In 1776, during the Revolutionary War, Gen. George Washington knew this same valley as the Hollow Way. Under his command, here began the main action of the Battle of Harlem Heights, to the disadvantage of British troops. Thirty years later, the propitious topography of the Hollow Way was more than favorable to give rise to a new American town.

In 1806, a village known as Manhattanville was established in the valley, which formed the sole break between today's Morningside Heights and Washington Heights. Straddling the famous Bloomingdale Road and Manhattan Street (present-day Broadway and 125th Street), the town became a conspicuous reference to city planners who were fervently limning a grid-patterned network of streets to the island's upper reaches. Manhattanville emerged as both

resort and suburb, and as a prominent residential, manufacturing, and transportation hub. By the mid-1800s, this picturesque locale was the convergence of river, railroad, and stage lines. Eight miles above city hall, in a New York widely referred to as the Empire City, Manhattanville was the uppermost touchstone of that city's pulse.

Although religious, educational, social, and philanthropic institutions characterized Manhattanville's autonomy, its close proximity to Harlem nurtured a flourishing partnership. St. Mary's Protestant Episcopal Church is Harlem's oldest religious institution in continuous service on the same site and is designated a New York City landmark. Also New York's first "free pew" Episcopal church, it boasts a long history of community activism and interracial membership. Such other institutions as the Academy of the Sacred Heart, Manhattan College, and St. Joseph's Roman Catholic Church made Manhattanville a compelling destination for Catholic immigrants from Ireland and Germany.

A diverse population has historically characterized Manhattanville. American patriots and British loyalists intermarried. Residents included slave owners, Quaker antislavery activists, and black abolitionists. Tradesmen, poor laborers, and wealthy industrialists commonly worshipped under the same roof. The town was a toehold for newly arriving Americans and a homestead of some citizens with ancient lineages.

Manhattanville's location stimulated the late-19th-century growth of Morningside Heights and Hamilton Heights on the crests of its valley. It rapidly began to lose footing to these famous neighbors and to fade in profile as a distinctive rural suburb. By 1904, with the opening of the new Broadway Interborough Rapid Transit (IRT) subway line, the town's radical transformation was galvanized. At long last, the "city in chase" had caught up with Manhattanville. And yet, surviving images abound to flesh out the ghost of this once formidable town.

This volume does not attempt to be a comprehensive study nor merely a valentine. It aspires to highlight, as a docent, a few of the people, sites, and events associated with a largely forgotten town whose role was invaluable in the social and urban growth of New York City. It is hoped that this book might encourage a deeper look into Manhattanville's significant role in America's constantly unfolding story and that it will relume some of the town's reputation and potential as "a place of considerable consequence."

—Eric K. Washington

One

MAKING INROADS

Manhattan Ville is now forming in the Ninth Ward of this city, on the Bloomingdale road, in front of Haerlem Cove . . . The corporation have opened a road, or avenue . . . from the North [Hudson] to the East-river . . . The proprietors of the soil are now laying out the streets, which are to be wide and open, to the Hudson river, where vessels of 300 tons may lie in safety.

—The *Spectator*, July 9, 1806

With Manhattanville's formation, the new village quickly became a significant suburban destination along the Bloomingdale Road. The next year, it was projected that "a Stage is to run daily between the city and town, the rates of which are to be very low." By river, it was advertised, "conveyances to and from the city by water will occur daily." The old Dutch passage through the valley improved in status as "the new road from the north river to Harlem town." Manhattanville's wharf became the convergence of river, railroad, and streetcar lines.

Manhattanville flourished naturally as a nexus of various transportation arteries. With the advent of rapid and mass transit in particular, transportation inevitably absorbed the town's ancient corridors, the ghosts of which today still haunt the modern thoroughfares of 125th Street, Broadway, and the noble currents of the Hudson River.

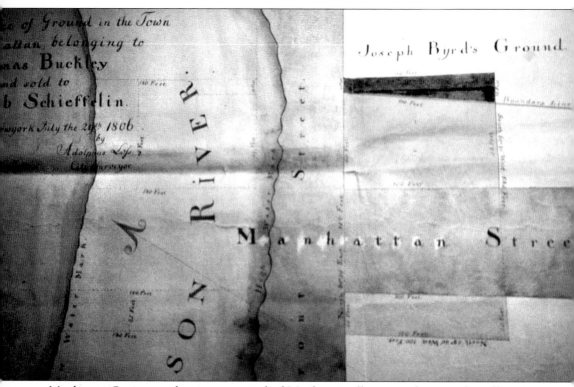

Manhattan Street was the signature road of Manhattanville, mapped out as the village was being established in 1806. This "new road . . . to Harlem town" followed an ancient, natural passage cleft through the topography and was widened and graded over time. Manhattan Street ran diagonally at a southeast bias from the Hudson River and then curved into the gridline route of 125th Street. These two roads formed a river-to-river link across Manhattan and a fluid circuit between the shoreline villages of Harlem and Manhattanville. (Schieffelin Family Papers, NYPL.)

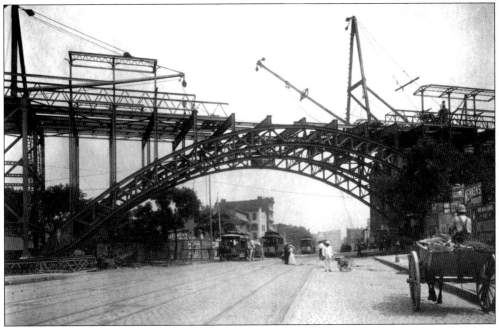

In 1903, New York City's first subway line, the Interborough Rapid Transit (IRT), neared completion along Broadway. The original system's only above-ground structure, engineered by William Barclay Parsons, was elevated over the valley in West Harlem at Manhattan Street, present-day 125th Street. The new subway opened on October 27, 1904. A year later, the *New York Herald* carried this headline: "Manhattanville Building Boom Resulted from Rapid Transit." The once rural Upper West Side had been overtaken by the city in chase. (Author's collection.)

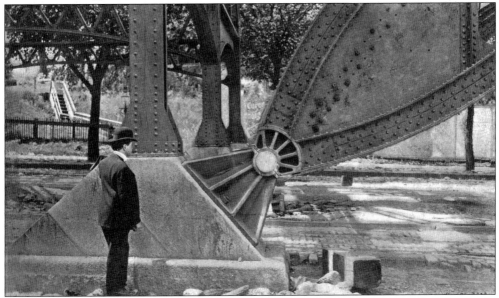

This picture from *Scientific American* shows one of the inclined iron plates called skewbacks supporting the main Manhattan Street subway arch as it receives inspection. In the background, a flight of timber steps zigzags from the Boulevard (Broadway) up the steep hill at 127th Street, present-day Tiemann Place. (Author's collection.)

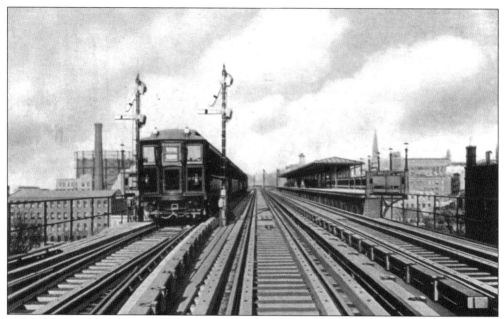

This 1905 postcard entitled "Between Tunnels" looks north along the line of tracks of the elevated subway station at Manhattan Street. Towering in the background are a smokestack of Sinclair & Valentine Printing Inks, an industrial drum of the Consolidated Gas Company, and the steeple of the Church of the Annunciation. (Author's collection.)

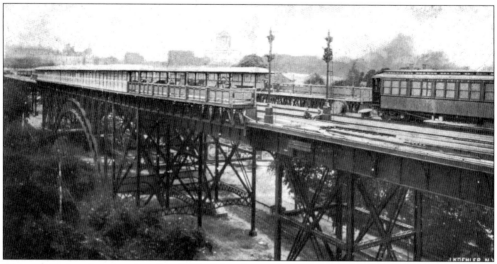

This 1906 view by photographer J. Koehler shows the eastern face of the Manhattan Street subway viaduct from Lawrence (126th) Street. Grant's Tomb looms faintly in the distance. (Author's collection.)

On August 25, 1885, the first electric cable car in New York City ran up 10th Avenue from West 125th Street in Manhattanville. The Third Avenue Railway Company, the richest railway company in the country, had constructed the line as an experiment and was persuaded to introduce the system into its eight miles of track along Third Avenue from the Harlem River to city hall. Cleaner and faster than horsecars, the cable car's successful trial run resulted in the city's first crosstown line, from Harlem to Manhattanville. (Author's collection.)

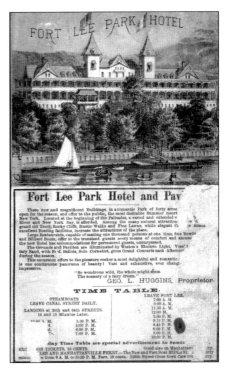

In the 1880s, the new Fort Lee Park Hotel attracted people across the river. This schedule on the hotel's advertising card advises people to take the 125th Street crosstown cars to the Manhattanville Ferry. This was also the longtime crossing to get to the Palisades Amusement Park. (Author's collection.)

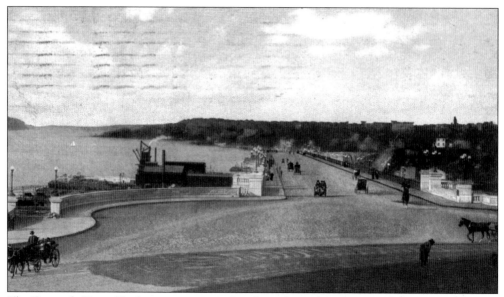

The Riverside Drive Viaduct was a point of pride in the early 1900s, as evidenced in postcards like the one above, by Irving Underhill, and the one below, by R.F. Turnbull. Both cards feature the new roadway's wide masonry southern approach. The historical significance of this site was recalled in 1910 as the Knickerbocker chapter of the Daughters of the American Revolution erected commemorative tablets here that read, "The Valley Crossed by this Viaduct was called in Washington's General Orders and in the Records of the American Revolution the Hollow Way. Here Began the Main Action of the Battle of Harlem Heights September 16, 1776." (Author's collection.)

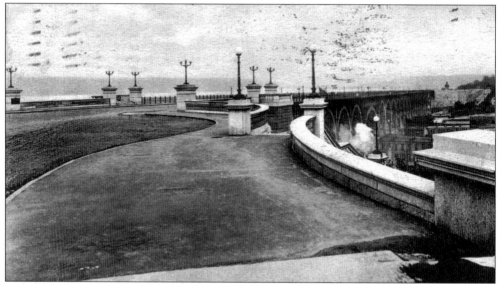

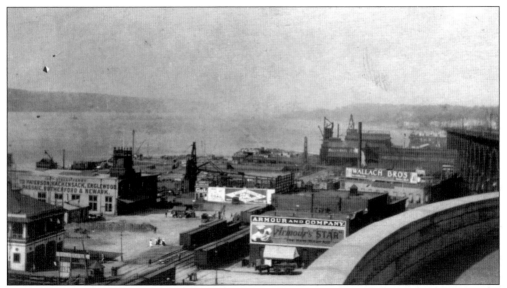

Beyond the Riverside Drive Viaduct's southern approach is a convergence of commerce and transportation. The tracks of the Hudson River and New York Central Railroads bisect the old Manhattanville docks. Capped by the short crested tower, the 130th Street Ferry terminal building was sometimes referred to as "the gateway to Bergen County," New Jersey. Bold print across the terminal's side reads, "To Paterson, Hackensack, Englewood, Passaic, Rutherford & Newark." (Author's collection.)

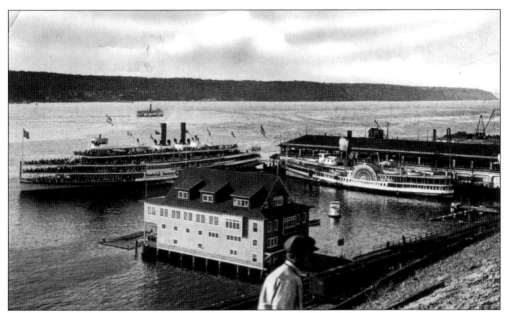

Excursion boats of the Hudson River Day Line also made Manhattanville a port of call. The sprawling *Hendrick Hudson* steamer, seen fairly dwarfing the Hudson Yacht Club in the foreground, plied the great river between New York and Albany. Seen also is a smaller paddlewheel boat of the Iron Steamboat Company, popular for ventures to Coney Island and Brighton Beach. (Author's collection.)

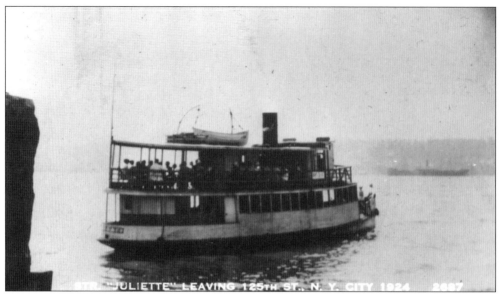

In 1920, the name Manhattan Street was dropped to make the route a continuation of 125th Street. In turn, the name on the former 130th Street Ferry house changed to the 125th Street Ferry. Locals generally continued to refer to the Fort Lee Ferry dock. But what's in a name? With seeming indifference, the *Juliette* is seen departing in 1924. (Author's collection.)

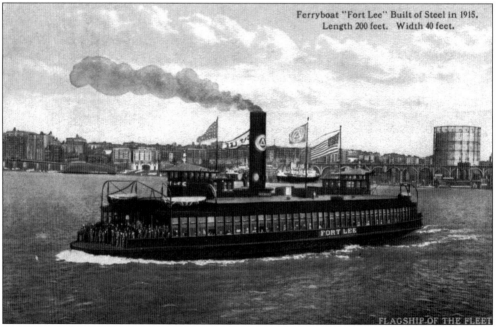

By 1915, the Riverside & Fort Lee Ferry Company was running regular service to Edgewater and Fort Lee, New Jersey. This postcard boasts of a steel vessel that the company had built that year. The *Fort Lee*, flagship of the ferryboat fleet, measured 200 feet long and 40 feet wide. (Author's collection.)

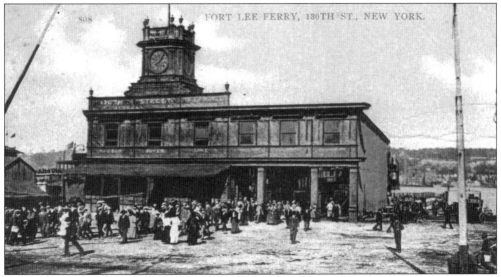

This early-1900s postcard shows the bustling Fort Lee Ferry house at 130th Street, across from the Manhattanville railroad depot. (Author's collection.)

"The people of Manhattanville and uptown looked at the train and kept silent and at last, precisely in time - three P.M. - the train glided into the new depot, and Mr. Lincoln was ready for his reception in the metropolis." —*New York Herald*, February 20, 1861.

This photograph shows Manhattanville's old railroad station at 130th Street in 1920, shortly before it was demolished. Newly elected president Abraham Lincoln arrived here on February 20, 1861, on his second visit to New York City. Some years later, the writer H.C. Bunner recalled "the loss the community had sustained in the death of President Lincoln" and its public expression of mourning on the day of April 25, 1865, when Lincoln's funeral train arrived at Manhattanville Station. (Schomburg Center for Research in Black Culture, NYPL.)

HUDSON RIVER R. R.

SUMMER RATES OF

COMMUTATION

Persons residing along the line of the Road, may obtain *Commutation Tickets* for both or either of the quarters commencing *May 1st* and *August 1st*, at the following **Reduced Rates:**

PLACES.	Price per Ticket, if 120 tickets per quarter are purchased.	Price per Ticket, if 80 Tickets per quarter are purchased.	Price per Ticket, if 50 tickets per quarter are purchased.
Manhattanville......	10 cents.	10 cents.	10 cents.
Yonkers............	11 "	14 "	16 "
Hastings...........	14 "	17 "	20 "
Dobb's Ferry........	16 "	20 "	21 "
Dearman...........	18 "	22 "	26 "
Tarrytown..........	18 "	22 "	26 "
Sing Sing..........	21 "	27 "	32 "
Croton............	23 "	29 "	34 "
Peekskill..........	27 ."	34 "	42 "
Cold Spring........	34 "	43 "	51 "
Fishkill...........	38 "	48 "	58 "
New Hamburgh.....	42 ".	53 "	63 "
Poughkeepsie......	48 "	60 "	72 "

The Tickets are not transferable, and are good only during the quarter for which they are issued.

A Ticket is to be surrendered by the Commuter every time he rides.

For Tickets apply at the office of the *Hudson River Railroad Company*, No. 54 Wall Street, New York.

New York, April, 1850.

This 1850 broadside advertises a price schedule for the new Hudson River Railroad. The route's first major northbound passenger stop was Manhattanville, with destinations continuing as far as Poughkeepsie. The New York Central & Hudson River Railroad maintained shuttle service, called the Dolly Varden Line, between West 30th Street and Spuyten Duyvil. (Author's collection.)

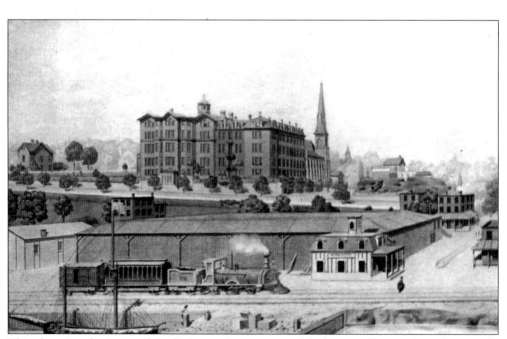

This charming depiction of the little wooden station at Manhattanville must have been made after the grading of Broadway and the remodeling of Manhattan College in the early 1870s. The steeple of the Church of the Annunciation also appears in the background. (Author's collection.)

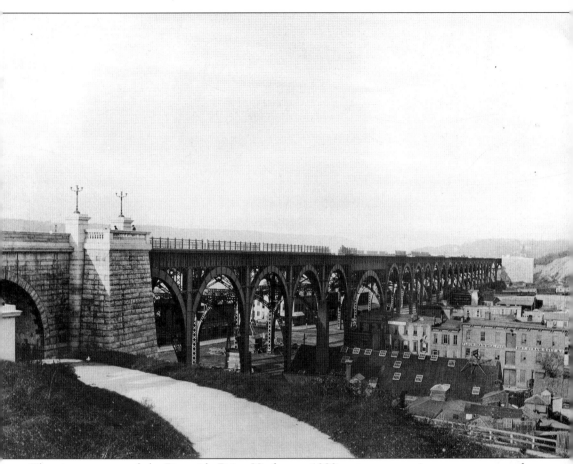

The city constructed the Riverside Drive Viaduct *c.* 1900 to connect an important system of drives in upper Manhattan. From West 72nd Street, Riverside Drive was called "one of the noblest city park-ways in the world." But the drive terminated at 129th Street, where it rounded Claremont Hill and returned. Beyond that point, the valley town of Manhattanville lay nestled in the only break between the bluffs of Morningside Heights and Washington Heights. The obstacle was finally overcome by a feat of engineering and a fantasy of masonry and metalwork. The completion of the Riverside Drive Viaduct extended the roadway to Boulevard Lafayette and realized a high-level boulevard that afforded "a continuous drive of ten miles along the picturesque banks of the Hudson and Harlem Rivers." (Author's collection.)

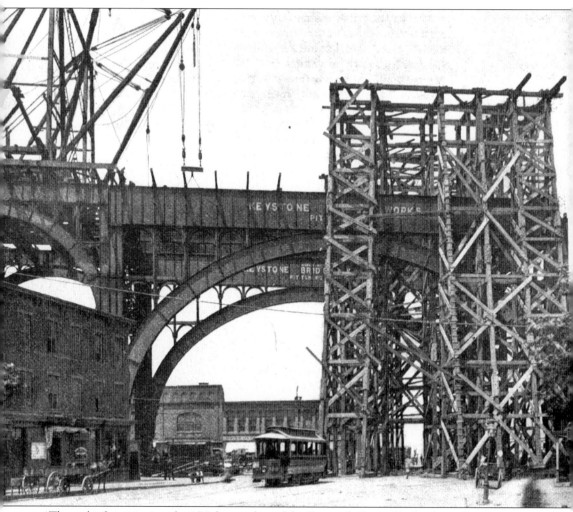

The task of positioning the 130-foot girders of the Riverside Drive Viaduct's steel causeway was delicate and dangerous. This photograph from *Scientific American* shows the construction under way in 1900. Traveling derricks lifted one end in sync with stationary timber scaffolding that lifted the other. (Author's collection.)

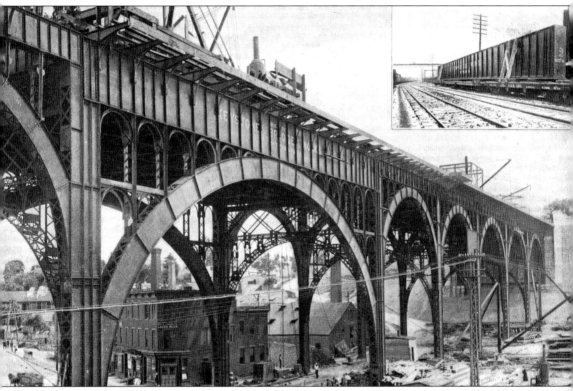

Another photograph from *Scientific American* in 1900 marvels at the construction of one of the most compelling features of the Riverside Drive Viaduct: the 130-foot-wide semicircular arch to span Manhattan Street. This arch was double the width of the other arches carrying the elevated road above 12th Avenue. In this picture, it also frames a local saloon and the smokestacks of the D.F. Tiemann Color Works in the background. The inset shows one of the two massive longitudinal plate girders. At 130 feet long, 10 feet deep, 3 feet wide, and weighing 62.5 tons, each of these metal elements required four flat rail cars for transport. (Author's collection.)

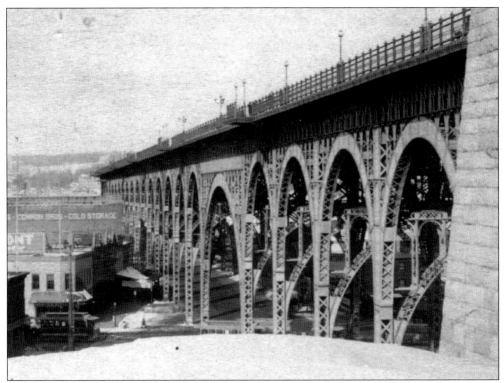

This c. 1900 view shows the west side of the Riverside Drive Viaduct at 12th Avenue. Going to and from the ferry, crosstown streetcars pass under the pylons and arches of filigreed steel at the foot of the snow-mounded Claremont Hill. (Author's collection.)

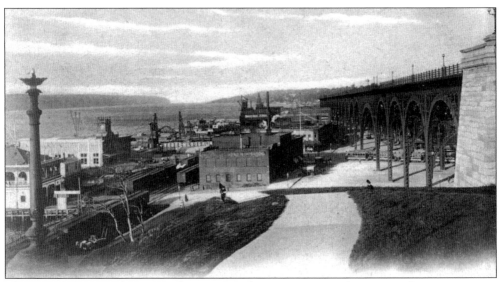

This 1905 Rotograph postcard captures the same scene from a wider perspective. (Author's collection.)

The new viaduct boasted several balconies built out at intervals from the upper sidewalks. This postcard from the early 1900s shows the view looking south toward Claremont and Grant's Tomb. The lamppost, ornately feathered with wrought-iron trim, betrays a Parisian inspiration. (George Baker.)

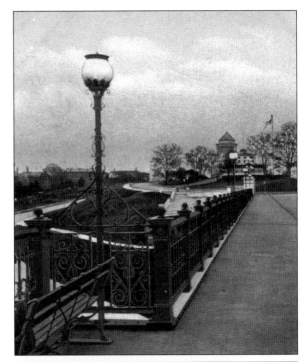

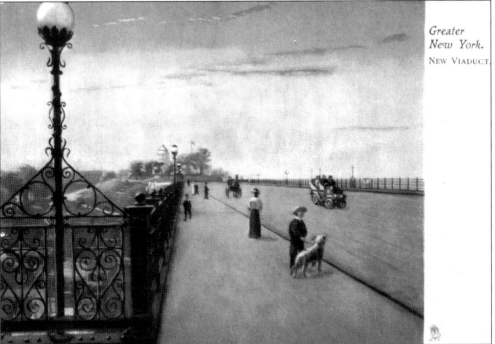

Greater New York. NEW VIADUCT.

The Riverside Drive Viaduct had appeal abroad, too. Inspired by the recent consolidation of the five boroughs in 1898, the English firm of Raphael Tuck & Son, "art publishers to their Majesties the King & Queen," published this "oilette" postcard in its "Greater New York" series. The viaduct became representative of the city's exponential growth in points of interest. (Author's collection.)

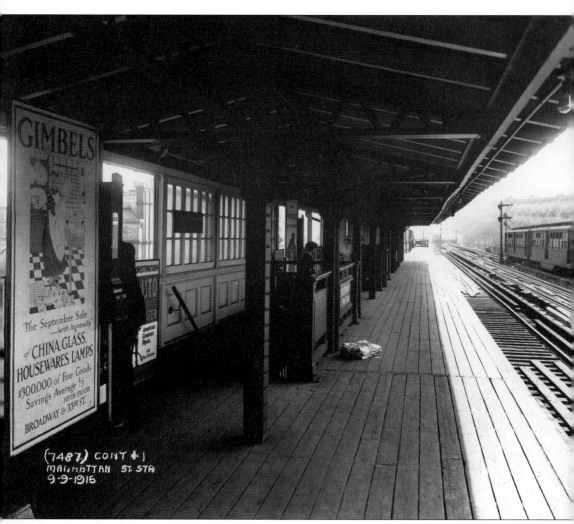

On the Manhattan Street subway platform, picture windows installed in the paneled walls along with advertisements provide a pleasant diversion from the waiting time for a train. (Author's collection.)

"Ancient Manhattanville is witnessing so radical a transformation that within a few years every evidence of old-time quaintness in that curious section of Harlem will be eliminated." —*New York Times*, July 7, 1912. The Broadway IRT line subway viaduct drew a fateful dash through Manhattanville's rural past and ushered in its urban future. "Manhattanville is experiencing something of a building boom at present. Flats and apartment houses will be the future structural features of that section of the city." —*New York Herald*, October 29, 1905. (Author's collection.)

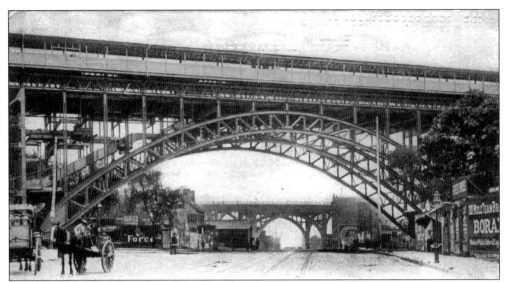

Still in use, the old Manhattan Street station is perhaps the most imposing exterior structure of the Broadway IRT. A popular architectural guide describes its latticed steel arch over today's 125th Street as "worthy of Eiffel," a distinct neighborhood and city icon since 1904. (Author's collection.)

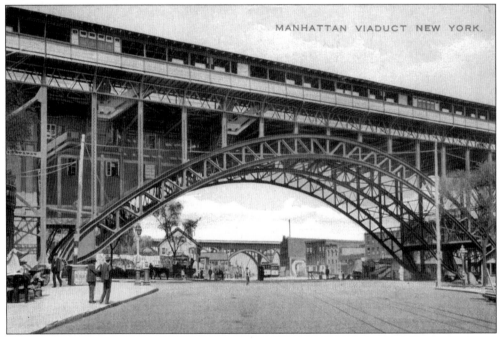

Two

PROMINENT FACES,
FACE VALUES

Entering where others feared to go . . . went one who deserves to be mentioned in connection with the history of Manhattanville . . . to nurse wherever asked.

—John Punnett Peters, D.D., *Annals of St. Michael's*, 1907

Manhattanville's notable ethnic mosaic, one of the community's most distinctive characteristics, recalls the ever-shifting diversity of its early Anglo-Dutch beginnings. An eclectic population of Europeans of French, Walloon, Danish, Swedish, and German origin, along with enslaved Africans, represented the first non-native settlers in New Harlem. In the 19th century, waves of immigration introduced great numbers of Irish and Germans who were in turn followed by great numbers of mostly Ashkenazic Jews from eastern Europe. By the early 20th century, African Americans were poised to reinvent the area's demographic profile again as their migration from lower Manhattan and southern states poured into central Harlem and overflowed into Manhattanville.

Inasmuch as the prominent faces pictured here all deserve mention, there are obvious omissions. Where visual records were inaccessible, available written records, even if only snippets, suggest profiles that await future inquiry. Some lacking faces connected to Manhattanville should include Mother Mary Aloysia Hardey, founder of the Society of the Sacred Heart's first convent in the East; John Hughes, the first Catholic archbishop of New York; Lucy Nicholls, the matriarch of three generations of an African American family active in the black male suffrage and abolition movements; Augusta Lewis Troup, women's suffragist and the first elected woman officer of a national union; Cornelius Van Wyck Lawrence, New York City's first publicly elected mayor (whose international and interracial household in 1855 included staff from Egypt, France, and Ireland); and a certain Mrs. Reid, who provided much needed aid during the 1832 cholera epidemic.

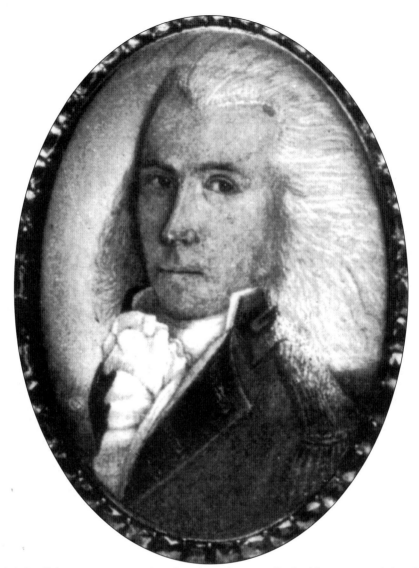

Lt. Jacob Schieffelin, a preeminent founder of Manhattanville, had been a British loyalist with the Detroit Volunteers during the Revolutionary War. Captured at the Battle of Vincennes, Indiana, in 1779, he was a prisoner of war for a year in Williamsburg, Virginia, until he escaped to British-held New York City. On July 15, 1780, his account of his capture in the *New-York Royal Gazette* condemned "the cruelty exercised by the Americans" upon the Native American warriors: "The dead carcasses of these unhappy fellows, were dragged to the river by this soldiery, some who had yet been struggling for life, after being thrown into the river. An Indian Chief of the name of Muckeydemonge, of the Ottawa nation, after Colonel Clarke had struck the hatchet in his head, with his own hands drew the tomahawk presenting it again to the inhuman butcher, who repeated the stroke." Schieffelin was the first to import Hennessy cognac to North America. He later founded a famous New York merchant house. In 1800, he sold Alexander Hamilton some of his uptown property to build the Grange. (St. Mary's Protestant Episcopal Church.)

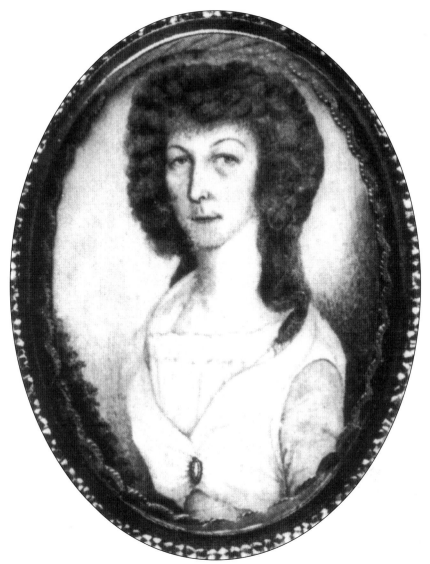

During that same period, Hannah Lawrence was a member of a prominent Quaker family in New York. Although ostensibly a pacifist, she carried out a rebellious act with a pen. She wrote a poem, "On the Purpose to which the Avenue Adjoining Trinity Church has of late been Dedicated, 1779," condemning the lewd conduct of British officers, and willfully dropped the anonymous verses on the sidewalk. The offense risked a hanging. When the British occupied the Lawrence home in August 1780, Hannah Lawrence encountered an unusual commanding officer: Lieutenant Schieffelin. The two eloped that September. They moved to Montreal but returned to New York in the 1790s. In 1824, Jacob and Hannah Lawrence Schieffelin donated a lot for the building of St. Mary's Protestant Episcopal Church, which had been founded the previous year. Today they lie buried under the church's porch. (St. Mary's Protestant Episcopal Church.)

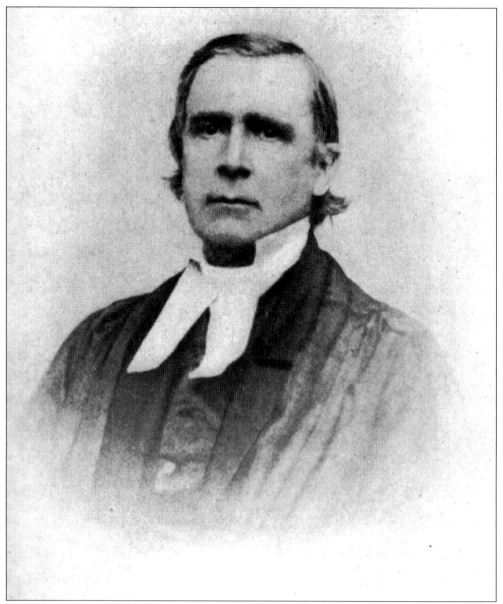

Rev. William Richmond was born in 1797 in Dighton, Massachusetts. He was rector of the affluent St. Michael's Episcopal Church in Bloomingdale when he began conducting Sunday school services for Manhattanville's poor children in 1820. In 1823, he helped found St. Mary's Protestant Episcopal Church and was made its first rector. In 1831, he originated the practice of holding religious services at mental institutions. He assumed the first chaplaincy of the nearby Bloomingdale Insane Asylum, where Columbia University now stands. When the city was gripped by a cholera epidemic in 1832, upper Manhattan was put under Richmond's authority and discretion to charge whatever was needed to care for the ill. Richmond's renowned and indefatigable missionary career took him downtown to the notorious Five Points, to the Far West territories of Oregon, and to the wilderness of the future Central Park, where a "Sunday School was established by me in the village of Seneca, inhabited by colored people." He died in 1858. (Author's collection.)

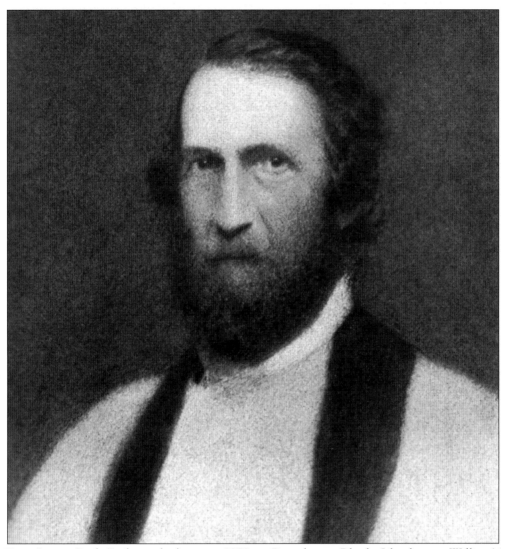

Rev. James Cook Richmond—born in 1808 in Providence, Rhode Island—was William's younger brother and the second rector of St. Mary's. His own religious calling, colored by "originality, learning and eccentricity," directed him on quests for spiritual scholarship throughout Europe, where he fraternized with the great poets Goethe and Lord Byron. At ease in 13 languages, Richmond's eloquence, even preaching in German, was renowned. His imprudent speaking abroad in support of Greek, Italian, and, later, Hungarian freedom struggles often rankled the authorities. He was impulsive, characterized as "essentially a preaching friar . . . restive under parochial restraints." In Rhode Island, Richmond elevated open-air preaching from novelty to legend among Episcopal clerics. In New York, he took an active part in the condemnation of Bishop Onderdonk. His zeal in joining a Civil War regiment as a chaplain in 1861 recalled an earlier mission to preach in Constantinople. The archbishop of Canterbury had advised that the Turks would reward such an errand with a beheading. "My head is ready," Richmond said, to which the cleric replied by calling him a lunatic. Later obituaries confirm this to have been a commonly held impression of the enigmatic Rev. James C. Richmond, who lived to retire peacefully on a farm in Poughkeepsie. He died there on July 20, 1866, at the hands of a disgruntled farmhand. (Author's collection.)

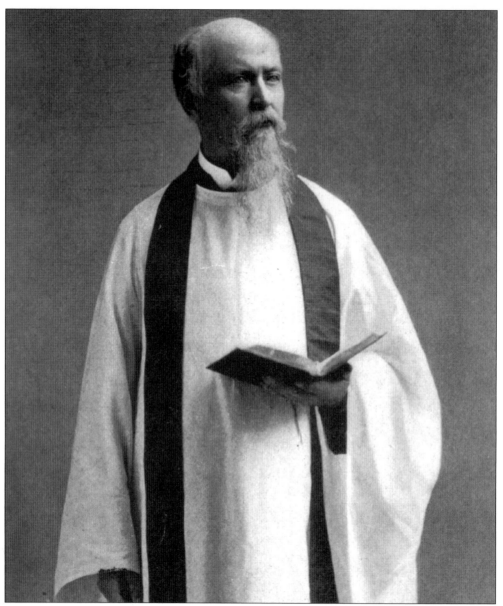

Rev. Thomas McClure Peters was another New Englander, born in 1821 in Boston, Massachusetts. Energetic and determined upon entering the General Theological Seminary in Chelsea in 1841, he volunteered his services almost immediately to William Richmond at St. Mary's in Manhattanville, where he eventually became the church's third rector. Long after St. Mary's became the first free church, Peters's devotion to establishing others was regarded as radicalism. Peters was instrumental in founding All Angels Church for the African American population in Seneca Village, the Manhattan Dispensary, and Manhattanville Library. At St. Mary's, he was reputedly the first to introduce a Christmas tree, still a novelty, for the poor. By the time of his death in 1893, his "proudest work" was in having founded the Sheltering Arms Asylum in 1864, which he relocated to Manhattanville in 1870, for children other institutions would not take in. (Author's collection.)

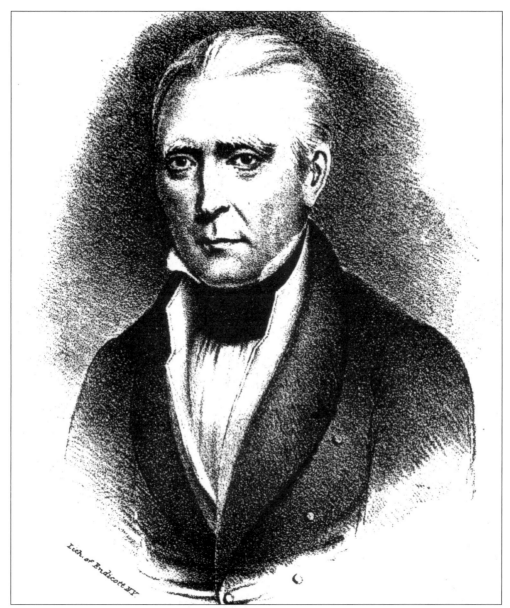

Wealthy merchant Michael Hogan—born in 1766 in County Clare, Ireland—made his fortune with the East India Company and was purported to be "the first Irishman of position and property who came to this country." In 1796, he was the owner and captain of the *Marquis Cornwallis*, a convict ship that trafficked the first known Irish political exiles to Australia, then a penal colony. A mutiny lasting seven days aboard the *Cornwallis* was brutally suppressed before the boat reached Port Jackson in New South Wales on February 11, 1796. After 1800, Hogan's involvement in the slave trade around southern Africa may have shipped "upwards of one thousand Negro slaves from Mozambique to someplace in the Southern United States." In 1806, Hogan bought a home just south of West 129th Street. He named it Claremont, either for his birthplace or for the residence of a fellow midshipman in the British navy, the Duke of Clarence (later King William IV). In 1819, Hogan was made the American agent for commerce and seamen at Havana, Cuba, by Pres. James Monroe. (Michael Hogan Styles.)

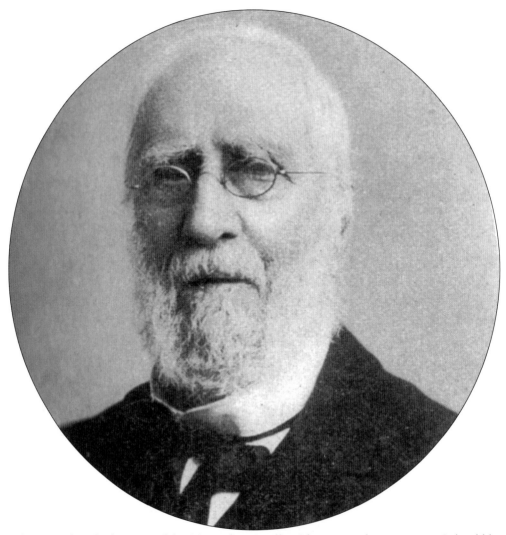

"If I succeed in the business of the Mayoralty as well as I have in making paint . . . I should be satisfied." —Hon. Daniel F. Tiemann (1805–1899), industrialist and mayor of New York City, 1858–1859.

In 1857, the bipartisan People's Union of Republicans and Democrats nominated Daniel Fawcett Tiemann for mayor of New York City. The reform-minded maneuver was successful. By an unprecedented number of votes, he ousted Mayor Fernando Wood, who was called by detractors the "master spirit" of the Tammany Hall Democratic machine. Tiemann's mayoralty oversaw the first successful connecting of the Atlantic cable, the designing of Central Park, and the cornerstone laying of St. Patrick's Cathedral on Fifth Avenue. He also originated the practice of hanging street names on lampposts. In an era of municipal corruption, Tiemann earned praise for his "honest" government, for his efforts to reform police, and for the processes by which commissioners and handlers of public funds were appointed. Wood returned to office after Tiemann, during which time a sheriff's sale to satisfy some financial fraud put up the contents of city hall for auction. Tiemann bought the properties and safeguarded them until the city could later reimburse him. Tiemann was married to the adopted daughter of fellow industrialist and reformer Peter Cooper (with whom he cofounded the Cooper Institute). (Author's collection.)

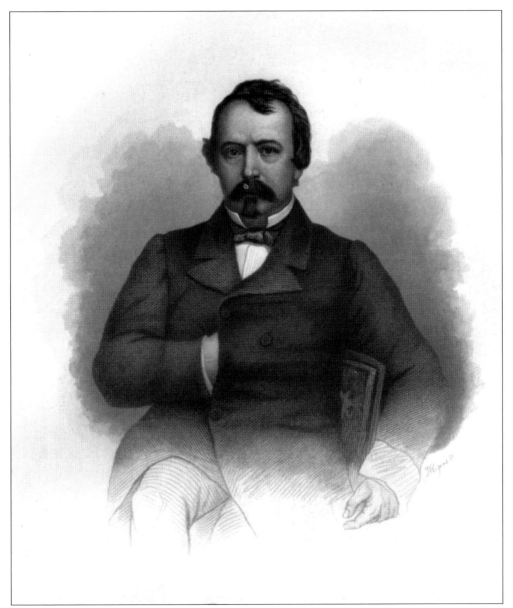

Clothier Daniel Devlin founded and headed one of the most honorably known ready-made clothing firms in the United States. When the Civil War required sending men to the battlefield by the hundred thousand at short notice, Devlin & Company of New York supplied much of the demand. Born and trained in business in Ireland, the young Devlin established himself in Louisville, Kentucky, in the 1830s, making jeans and other retail clothing. In 1844, he founded a clothing company in New York that would rival Brooks Brothers. He innovated a quick manufacturing system that produced fine-quality, ready-made clothing on a large scale, and at less expense than previously. "His probity and business talents" were widely appreciated, and he was known as a generous benefactor to the Catholic Church. Craigmoor, his Italianate villa in Manhattanville, stood at 138th Street and Broadway. On December 2, 1860, the acting mayor during Fernando Wood's temporary absence removed the city chamberlain (treasurer) to appoint Devlin to the post. Devlin died in office at age 54 on February 22, 1867. (Author's collection.)

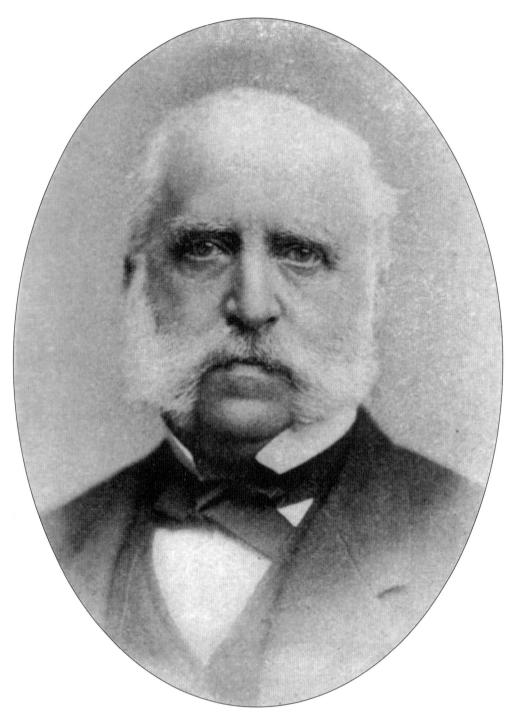

Oswald Ottendorfer was the president and editor of the *New Yorker Staats Zeitung,* the preeminent daily of the city's large German-speaking population. The paper's influence, however, even extended back to Berlin, Germany. In 1884, he founded the Ottendorfor (or Second-Avenue Branch) Library in the heart of *Kleindeutschland,* or Little Germany, that is today's East Village. His estate was at 136th Street and Riverside Drive. (Author's collection.)

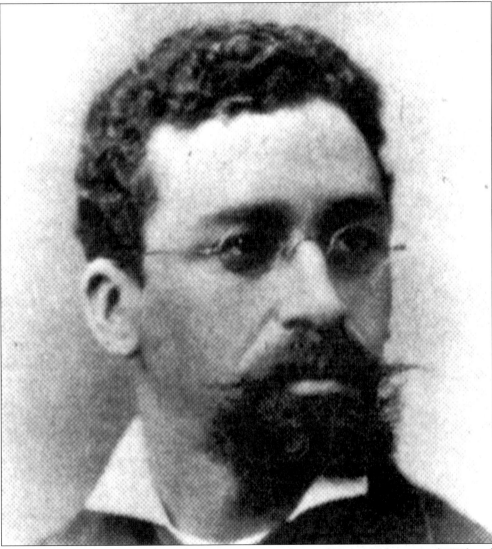

Richard T. Greener was the first African American graduate of Harvard University (1870) and served from 1898 to 1905 as the U.S. commercial agent at Vladivostok, Russia. Upon the death of his friend Ulysses S. Grant in 1885, Greener became secretary of the Grant Monument Association and, until 1892, spearheaded the campaign to erect the proposed Grant's Tomb. Greener successfully fended off efforts of other cities in order to ensure the placement of Grant's Tomb in New York. He organized the design competition for the monument in 1888 and, when submissions appeared unworthy, organized another. The result was the present monument, dedicated in 1897. The legacy of Greener's efforts today remains one of the most recognized landmarks to visitors of the city. (National Park Service.)

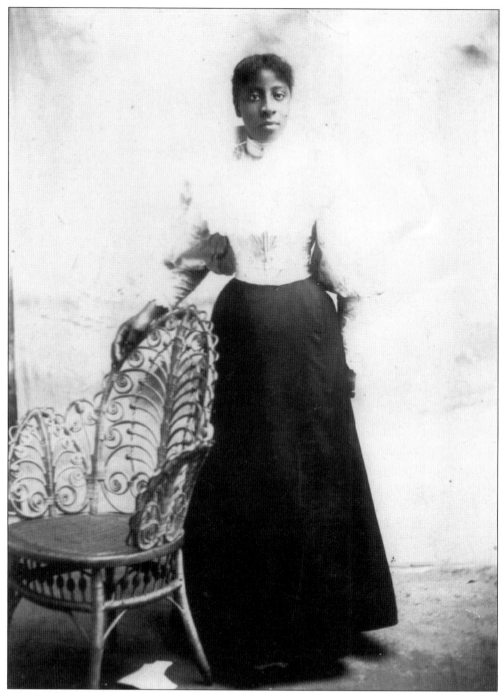

This is a cabinet card of an unidentified African American woman in the 1890s. She was likely to have lived near the Simpson studio, where the photograph was taken at 164 West 125th Street, just off Seventh Avenue on the eastern fringe of Manhattanville. Blacks arrived in New Harlem during the 17th-century Dutch colonial period and resided throughout the area well before Harlem's identification in the 1920s as the country's most significant African American community. (Author's collection.)

Three

THE THREE R'S
AND THE GOLDEN RULE

*The transformation of this school from an ordinary loghouse, which was the first
structure, into one of the finest schools in New-York forms an interesting
study in the development of this part of Manhattan Island.*

—*New-York Daily Tribune*, April 12, 1895

For most of the 19th century, Manhattanville was the aggregate center of numerous educational, religious, social, and philanthropic institutions, decades before that distinction would shift to the newly coined "Morningside Heights." Some traces remain. In 1806, Jacob Schieffelin opened the new village's first school, the Academy, described as "an excellent school . . . constantly kept up, under the superintendence of trustees." Although it was out of use by 1813, it was followed by Thomas M. Finley's Manhattanville Boarding School and Scientific Academy. Anticipating the present public school system, the Free School Society of New York City, incorporated in 1805, became the Public School Society in 1826, which the next year incorporated several free schools, including the Harlem, Yorkville, Hamilton, and Manhattanville Free Schools—the last evolving into Public School No. 43, which stands on its original site.

Manhattanville was also home to two of the most important Roman Catholic educational institutions of higher learning in 19th-century New York: the Academy and Convent of the Sacred Heart (Manhattanville College) and Manhattan College. Under the influential force of John Hughes—New York's first Catholic archbishop, who saw the city's public schools as mere proponents of Protestant doctrines—some of the city's earliest parochial schools were established in Manhattanville as well. These included the Annunciation School of the Christian Brothers and St. Joseph's Roman Catholic School.

By the beginning of the 20th century, other learning, eleemosynary, and health institutions—like the Sheltering Arms Home and Manhattan Hospital—had established their formidable reputations in Manhattanville.

This photograph of Thomas Finley's schoolhouse was taken on May 23, 1901. It was here that, shortly following Finley's death on November 28, 1823, his widow, Frances, organized the founding meeting of St. Mary's Church on December 18, which was, in that year, Thanksgiving Day. Frances Finley is said to have "kept the grass fresh and the flowers blooming until 1872," when she died at age 101. When the IRT Broadway line opened in 1904, ushering in a tide of development over Manhattanville's pastoral traces, Finley's schoolhouse still commanded this hill just west of Broadway at 125th Street. (Schomburg Center for Research in Black Culture, NYPL.)

MANHATTANVILLE BOARDING SCHOOL AND SCIENTIFIC ACADEMY.

THOMAS M. FINLEY.

INFORMS his friends, that the above institution will open on the first Monday in May next, for the reception of Boarders in the tuition of the elegant and useful branches of Literature, including the Arts and Sciences, viz :—Reading, Writing, English Grammar, Mercantile Arithmetic and Elocution, Geometry, Plane and Spherical Trigenometry, Surveying, Guaging and Mensuration of Timber, Algebra, Book-keeping, Geography, Astronomy, Navigation and Lunar Observations, Greek, Latin and French Languages, designing, Drawing and Painting.

For terms of Tuition in the above branches of Literature, apply to Dr. Peter Wilson, Columbia College, Mess. T. & J. Swords, Pearl-street, Gould Banks & Gould, corner of Wall and Broad streets, and Matthias Ward, stationer, Broadway, New-York.

N. B. The Manhattanville Stages leave Manhattanville and the City Hotel, Broadway, at 8 o'clock A. M. and 5 P. M. every day, Sundays excepted. Ap 28

An 1813 announcement in the *New-York Evening Post* informed of the opening of the Manhattanville Boarding School and Scientific Academy. (Author's collection.)

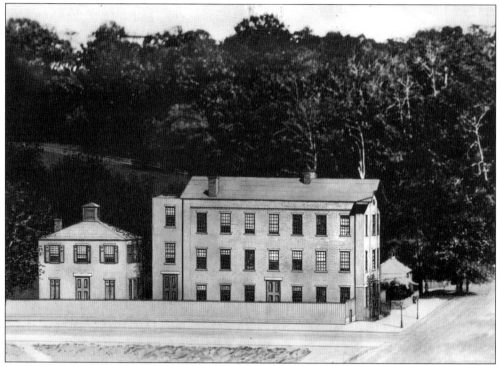

The Manhattanville Free School and Public School No. 43, shown in this undated view, had their beginnings in the early 19th century, when some of Manhattanville's wealthy "country gentlemen" established the school for the children of their hired farmers, stablemen, and tradesmen. From 1827 until 1850, the Manhattanville Free School was a solitary little schoolhouse facing 129th Street. It was joined c. 1854 by the larger Public School No. 43, facing 10th (Amsterdam) Avenue. (St. Mary's Protestant Episcopal Church.)

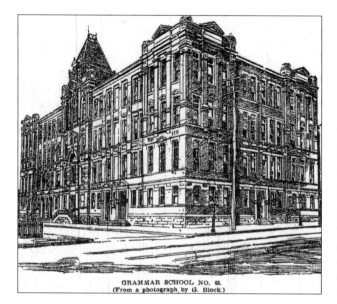

GRAMMAR SCHOOL NO. 43.
(From a photograph, by G. Block.)

In 1895, the *New-York Daily Tribune* described the displacement of the two small schoolhouses by a "first-class" modern and commodious stone building. Its cornerstone was laid 10 years earlier with a copper box holding the school's complete history. This new "magnificent schoolhouse" gave way itself *c.* 1934 to the current Adam Clayton Powell Intermediate School No. 43. However, the words "Manhattanville Junior High School" chiseled above the entrance still attest to the school's provenance as one of the oldest in the city. (NYPL.)

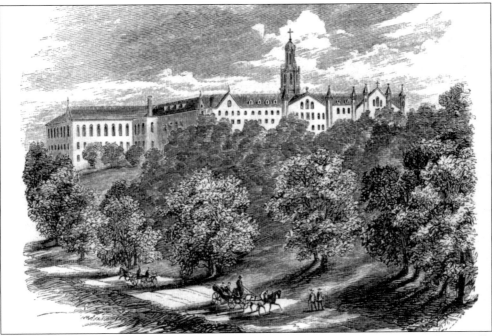

In 1847, the Ladies of the Sacred Heart purchased tobacconist Jacob Lorillard's Manhattanville farm. The Academy and Convent of the Sacred Heart incorporated in 1851 and adapted the "elevated, healthy, and beautiful" property for recreation and promenade. The grounds were "cultivated and spacious, surrounded by shrubbery, and pleasantly shaded by grove and forest trees." Enrollment opened to 325 "young ladies of the highest class" as boarders, and an adjacent day school offered free instruction to 300 others from the area without religious requirement. (Author's collection.)

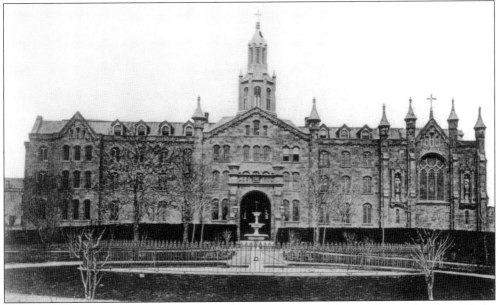

In 1888, a fire destroyed much of the Academy of the Sacred Heart. (Schomburg Center for Research in Black Culture, NYPL.)

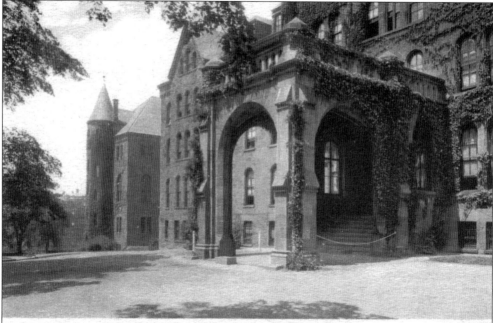

COLLEGE OF THE SACRED HEART MANHATTANVILLE, N. Y.

The entrance to the College of the Sacred Heart is pictured in the early 1900s. Pupils pursued "all the useful and ornamental branches becoming their sex" at the convent school, which later became the College of the Sacred Heart and, later still, Manhattanville College. (Author's collection.)

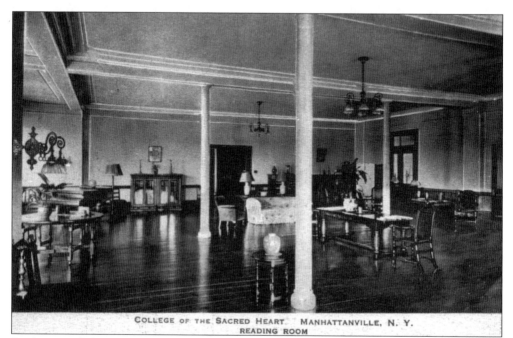

COLLEGE OF THE SACRED HEART MANHATTANVILLE, N. Y.
READING ROOM

Students used the reading room of the College of the Sacred Heart. (Author's collection.)

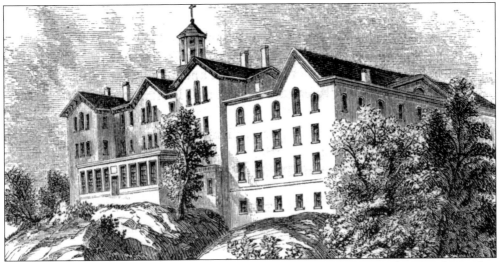

David T. Valentine's *Manual of the Corporation of the City of New York* pointed out that Manhattan College's "location is not surpassed in landscape, beauty or salubrity." Commanding a natural pedestal of rocks at the northeast corner of Broadway and 131st Street, its western side faced a vista that comprised the Hudson River and "some of the grandest and most picturesque scenery." On the other side, "the hum and bustle of the busy world are excluded by sloping hills and shady groves, the tout ensemble of which . . . is well calculated to give to the youthful mind a studious and thoughtful turn." (Author's collection.)

Manhattan College developed as Irish and German immigration in the 1840s swelled New York's Catholic population. In 1853, members of the Christian Brothers, a Catholic order from France, took over Newbold Lawrence's mansion at the northeast corner of Broadway and 131st Street. They adapted the building into a boarding school—the Academy of the Holy Infancy, which eventually became Manhattan College. The southern wing of the building was greatly remodeled in 1872 after Broadway was cut through. The building was demolished in May 1926, whereupon the school moved to its present location in the Bronx. Manhattan College graduated notable men of the cloth, such as Cardinals Hayes and Mundelein; notable justices Dowling, McAvoy, and Cohalan; and Dr. William L. Ettinger. (Schomburg Center for Research in Black Culture, NYPL.)

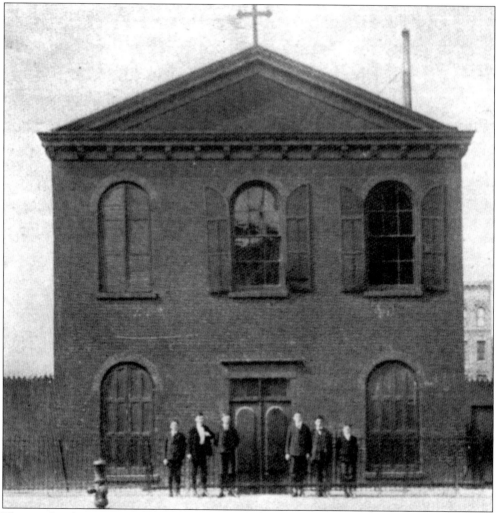

This is the Annunciation parochial school established by the Christian Brothers, shown sometime between 1880 and 1900, where it stood on the south side of 131st Street between 10th Avenue and Old Broadway. In 1886, Fr. Jeremiah Griffin loaned the two-story brick schoolhouse to temporarily relieve the overcrowded male ward across the street from Manhattan Hospital, whose annual report noted, "Many cases were there treated." (Church of the Annunciation.)

The Manhattan Dispensary was established in early 1862 as wounded Union army soldiers from Civil War battlefields were making painful progress home up the Bloomingdale Road. Dr. Louis A. Rodenstein set up a temporary hospital on Claremont Hill. Then, on May 23, 1862, he incorporated the Manhattan Dispensary for any New Yorkers living north of 72nd Street in need of medical and surgical aid "and unable by reason of poverty to procure the same." In this *c.* 1869 view, the location of the dispensary is mislabeled. It was located at the northwest corner of West 125th Street and 10th Avenue (now LaSalle Street and Amsterdam Avenue). (Author's collection.)

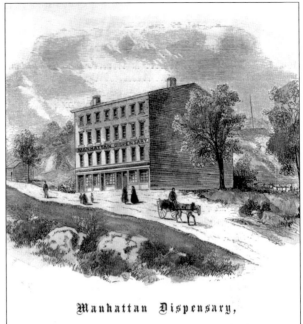

Manhattan Dispensary,

Corner of One Hundred and Thirty-first street and Tenth avenue.

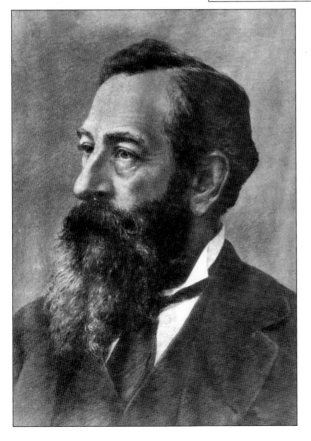

Dr. Louis A. Rodenstein was born on February 19, 1834, in Frankfort, Germany. His family moved in 1842 to New Orleans and then settled in Austin, where Louis eventually attended the school of Dr. Anson Jones, the last president of the Republic of Texas. He followed his medical degree from the University of Pennsylvania with a private practice in upper Manhattan, riding a pony from house to house. On May 16, 1861, he married Sarah Cooper Tiemann, daughter of former mayor Daniel F. Tiemann. In Manhattanville, Rodenstein was also visiting physician to the Sacred Heart convent and the Hebrew Orphan Asylum. For the 75th anniversary of Knickerbocker Hospital in 1937, the doctor was fondly recalled: "He was a fine man with a heart as big as a house." (United Hospital Fund.)

47

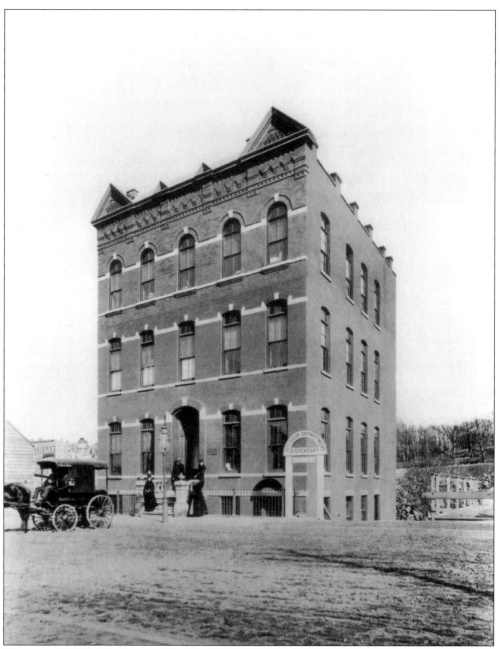

The large brick, fully equipped Manhattan Dispensary Hospital opened for public service on December 12, 1885, on 131st Street just west of Amsterdam Avenue. With the growth of manufactories and workshops, and the appearance of nearby elevated railroads, accidents had increased. Rodenstein emphasized "the need long felt in that part of the city for such a hospital." The *New York Times* praised the "great success" of the hospital, "the only general hospital north of 99th street." Manhattan Hospital covered the largest ambulance district in the city, having a territory three times greater than that of any other hospital. The annual report of 1886 boasted, "Every call was answered without delay." (Schomburg Center for Research in Black Culture, NYPL.)

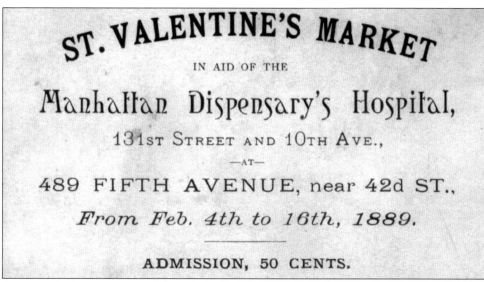

ST. VALENTINE'S MARKET

IN AID OF THE

Manhattan Dispensary's Hospital,

131st STREET AND 10TH AVE.,

—AT—

489 FIFTH AVENUE, near 42d ST.,

From Feb. 4th to 16th, 1889.

ADMISSION, 50 CENTS.

Particular kudos went to the hospital's Ladies' Association, founded in June 1886 with Mrs. J. Hood Wright as president, whose fundraising contributed an essential $10,000 toward both the building fund and to the fixtures of the $13,000 new facility. In February 1889, the Ladies' Association held its St. Valentine's Market; the $11,000 net went to establish a permanent endowment for the hospital. Inventor Thomas A. Edison's daily participation helped to assure the fair's end in "a blaze of glory." Manhattan Hospital warmed the community with smaller touches. When a Hudson River Railroad freight car violently injured a worker in August 1891, doctors succeeded in grafting skin from of one of the man's legs to the other, preventing an amputation. But when the patient stopped the painful procedure before completion, the hospital's senior surgeon offered skin from his own leg. Other associate staff members readily volunteered to emulate the self-sacrificing gesture. (Author's collection.)

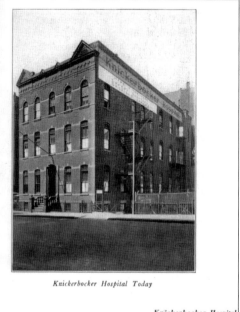

Knickerbocker Hospital Today

Knickerbocker Hospital wants dollars for quarters

In 1895, Manhattan Dispensary Hospital was renamed in memory of its late president, J. Hood Wright (1887–1894), also a generous benefactor. In 1913, Wright's wife and sister urged the less personal sounding name-change to Knickerbocker Hospital. "Dollars" were sought in this fundraising brochure during a campaign for "Larger Quarters Deserved and Needed." (United Hospital Fund.)

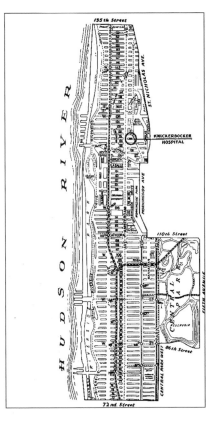

This 1937 map shows Knickerbocker Hospital's four square miles of ambulance district, for many years the largest of any in Manhattan. It covered a population of about 300,000 people from 72nd Street to 155th Street, between Eighth Avenue and the Hudson River, and an upper portion of Central Park. (United Hospital Fund.)

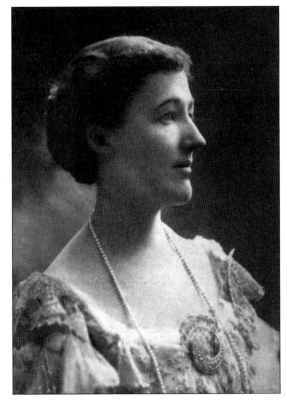

Mary Robins, the stepdaughter of J. Hood Wright, was among a number of women, including her mother, whose roles on the Ladies' Association board made them formidable hospital benefactors in their own rights. Other long associates of the hospital included Isidor and Ida Straus, the Macy's Department store owners, who perished together on the *Titanic* in 1912. (United Hospital Fund.)

50

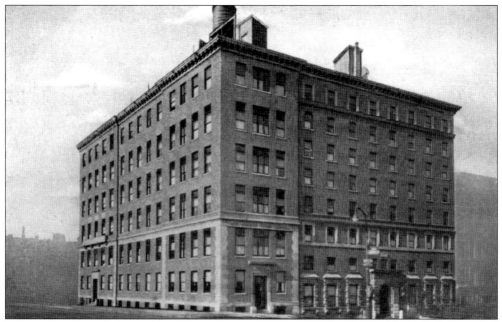

In 1913, friends of Knickerbocker Hospital donated three automobile ambulances to replace the horse ambulances. In 1918, the year of the influenza epidemic, ambulances responded to 4,197 calls. Under Dr. William Duncan Silkworth in the 1940s, a special hospital ward opened that combined medicinal techniques in the treatment of alcoholism, making the hospital a pillar in the establishment of Alcoholics Anonymous. In 1988, Rev. Dr. M. Moran Weston, an influential social welfare activist and former rector of St. Philips Protestant Episcopal Church, transformed the languishing hospital building into an assisted-living residence for seniors. The transformation perpetuates Knickerbocker Hospital's philanthropic mission begun in old Manhattanville's gaslight era. The photograph below, taken in 1942, shows the hospital emergency unit and equipment. (United Hospital Fund.)

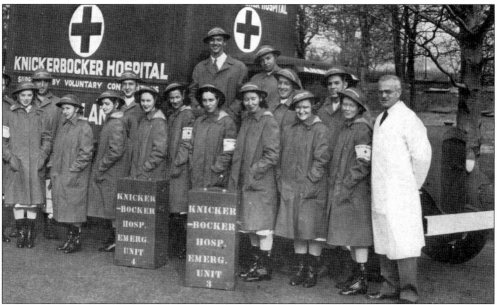

COLLEGE OF THE SACRED HEART MANHATTANVILLE, N. Y.

Shown *c.* 1900 is the College of the Sacred Heart, rebuilt on the same grounds where it had burned down in 1888. By 1900, surrounding development had progressed rapidly. The building, especially from a distance, continued to dominate the summit of Convent Hill, overlooking Manhattanville most impressively. (Author's collection.)

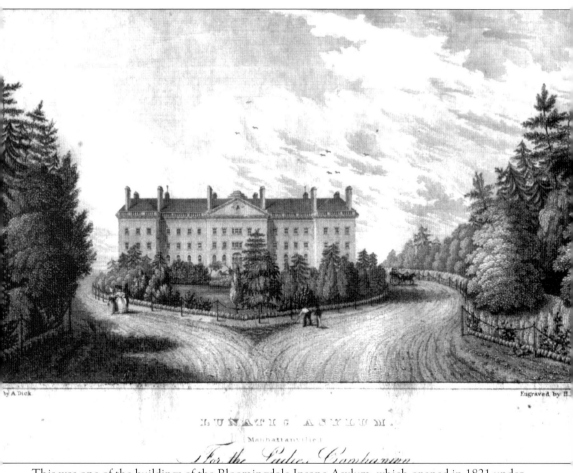

LUNATIC ASYLUM.
(Manhattanville)
For the Ladies Companion

This was one of the buildings of the Bloomingdale Insane Asylum, which opened in 1821 under the auspices of New York Hospital. Its location at about Broadway and 116th Street (where Columbia University now stands) was long known as Asylum Hill. It was commonly associated with the Manhattanville area before the term "Morningside Heights" was used. (Author's collection.)

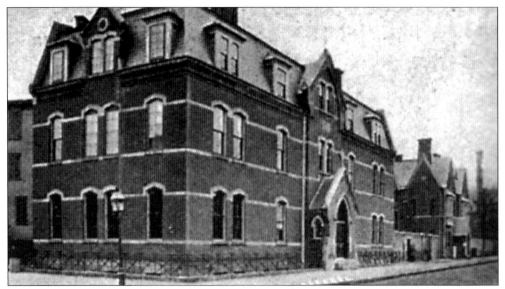

In 1864, Rev. Thomas M. Peters, while rector of St. Michael's Protestant Episcopal Church, organized the Sheltering Arms Asylum out of his home near West 100th Street. It was a free haven for those homeless "children in the midst" for whom other charitable institutions did not provide. Some were rejected due to incurable illnesses, some abandoned. Others were so-called "half-orphans" whose parents required temporary assistance while striving to overcome abject poverty or other adversities. (Author's collection.)

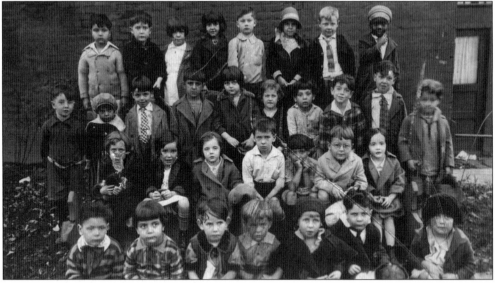

The cutting of Broadway through Reverend Peters' grounds forced the Sheltering Arms to relocate. On March 6, 1869, the cornerstone was laid at West 129th Street and 10th Avenue, and the Sheltering Arms children moved into their first custom-built home on February 5, 1870. The building's plan was inspired by the innovative "rough house" cottages in Wichern, near Hamburg, Germany, which dispersed children into equally numbered "families." Architect Charles C. Haight's more economical alternative was a single, two-story, brick Gothic Revival building composed of five sections; the slated mansard roof would house a third story. (St. Mary's Protestant Episcopal Church.)

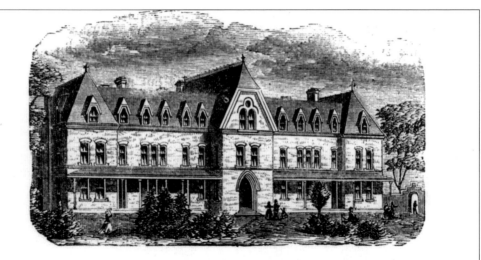

THE SHELTERING ARMS.

(Manhattanville.)

INSTITUTIONS for the relief of orphans, half-orphans, the aged, sick, and blind, have greatly multiplied in New York during the last fifty years; yet a few observing minds discovered that there still existed a large and helpless class in the community, to whom no door of generous hospitality was open. Each Institution being established for the relief of a single class, always sufficiently numerous to tax it to its utmost, others, equally needy and worthy, were necessarily excluded. The asylum for the blind, and the one for the deaf-mute, received inmates at a certain age, but where were the poor homeless children to spend their earlier years? There were hospitals for sick and crippled children, as long as surgeons pronounced them curable, but incurables could not be admitted. Some institutions received half-orphans, or poor children, free, on condition that they were surrendered to the institution; but many parents, in pressing need of temporary relief, were unwilling to irrevocably surrender their children. The half-orphan asylum could not receive the children of the father deserted by his wife, of the wife abandoned by her husband, nor of parents who were both sick, in the hospital. These considerations led to the founding of the Sheltering Arms, an institution which pro-

In 1873, the Sheltering Arms was highlighted over several pages in *New York and Its Institutions*. Unlike many institutions, the Sheltering Arms did not require parents to surrender their children for good. It received up to 120 children at a time from infancy to the age of 14, "subject to the call of their parents or relatives," regardless of creed or nationality. (St. Mary's Protestant Episcopal Church.)

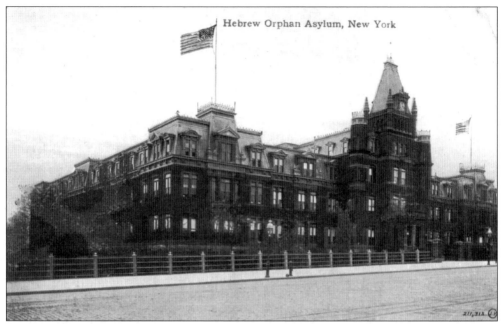

The Hebrew Benevolent and Orphan Asylum, shown *c.* 1890, incorporated in 1822. Its permanent home was built in 1883 at Amsterdam and 136th Street. Art Buchwald was among the notable residents of the privately endowed and supported home for orphans. (Author's collection.)

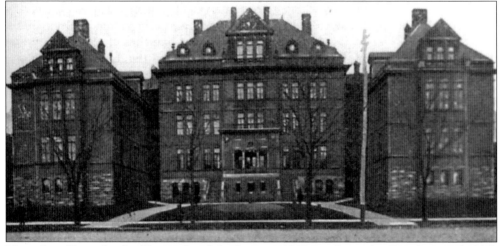

Montefiore Home for the Chronic Invalids, shown *c.* 1890, was located at Broadway and 138th Street. The home was a Jewish charity that cared for men and women unable, due to incurable disease, to obtain care from other institutions. (Author's collection.)

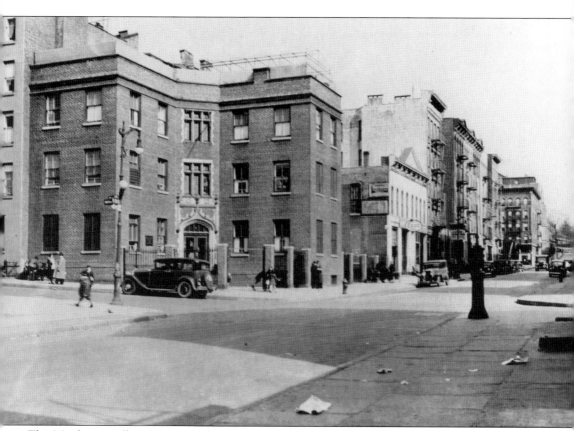

The Manhattanville Nursery on the northeast corner of Old Broadway and 131st Street was established in 1916 to relieve burdened local households. It served as a playground, day nursery, temporary night and day shelter, kindergarten, and nursery school. Part of the institution's creed stated in an early bulletin that "the family is the strategic point of economic efficiency." During a weeklong campaign in 1916 to raise a $40,000 building fund, a little tomato-shaped bank was presented by some mothers whose children the nursery cared for. It contained $6.31, the inspirational seed for over $51,000 more raised. (NYPL.)

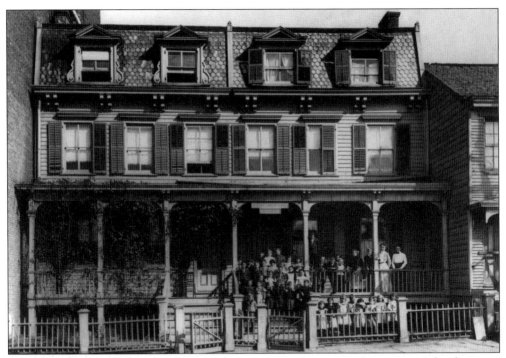

Mansion House, on West 129th Street, was the first home for the Speyer School. It was organized as a laboratory school for Teachers College to combine the functions of experimental curriculum and practice. (Teachers College, Columbia University.)

Banker James Speyer and his wife, Ellen P. Speyer, were notable philanthropists. They relieved the school's makeshift situation in a 129th Street frame house by donating a custom-made, five-story building on Lawrence Street. (Author's collection.)

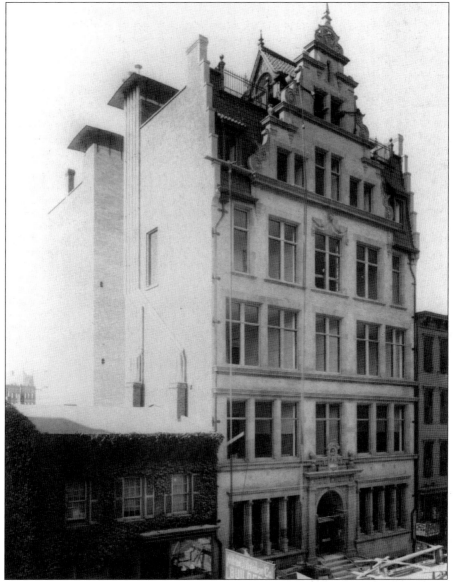

This photograph shows the new Speyer School building on Lawrence Street (514 West 126th Street) near Amsterdam Avenue while it was under construction in 1902. The school acted as a settlement house. It furnished community recreation space so as to keep in touch with graduates and the neighborhood's longtime residents and retained a corps of resident workers. On March 20, 1948, after being relinquished from Teachers College and renovated by Columbia University for community work, the building reopened as the Manhattanville Neighborhood Center. In 1964, St. Mary's Episcopal Church bought the building which, operating as the Ackley Community Center, ran educational and after-school programs and provided curriculum preparation space to the Afro-American History Caravan, which made the rounds of Harlem schools. The center availed spaces to diverse neighborhood and parent committee groups. It housed youth-employment services, a Headstart and day-care program, and a college scholarship program. Today, St. Mary's operates the Speyer Building as an AIDS hospice. (Teachers College, Columbia University.)

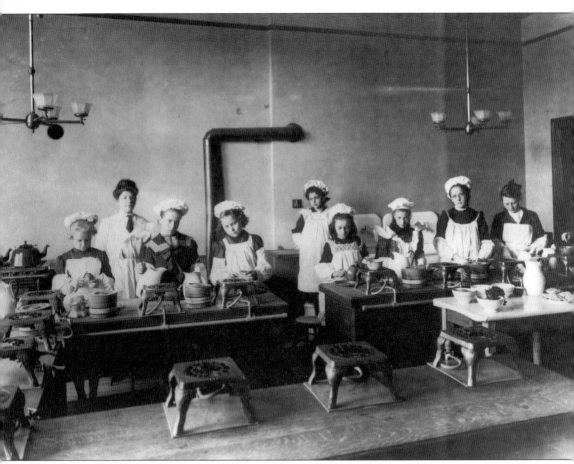

In a cooking class at the Speyer school *c.* 1905, these young girls are learning a few techniques in home life. Other focuses of the school's curricula included nature study, geography, and arithmetic. (Teachers College, Columbia University.)

Four

HIGHER AUTHORITIES

Until the organization of the St. Mary Episcopal Church,
at Manhattanville, in 1823, the Reformed Church was the only
one of any denomination within the entire limits of Harlem.

—James Riker, *Harlem: Its Origin and Early Annals*, 1881

Many of Manhattanville's historic religious institutions are still active. The oldest and first is St. Mary's Protestant Episcopal Church, organized in 1823. Although a Quaker meetinghouse existed in the area in 1810 and 1811, it was probably only for "indulged" meetings of worship without a business agenda and was short-lived. This left St. Mary's to be Manhattanville's only church through the second quarter of the 19th century. Established by the affluent St. Michael's Episcopal Church in Bloomingdale, St. Mary's was incorporated as an independent parish. Its congregation was a mix of rich and poor, white and black.

In 1852, as benefit assessments were being made for the cutting through of the Boulevard (Broadway), the African Methodist Episcopal Church held title to several Manhattanville lots through trustees. It did not establish a church there, but one notable trustee of record was the abolitionist Epiphany Davis, a founder of the free-black settlement of Seneca Village.

In 1854, the order of the Christian Brothers established the Church of the Annunciation, the first Catholic church built above Second Street on the west side. The church catered to the predominantly Irish workers of the new Hudson River Railroad in particular. It stood adjacent to Manhattan College, which the Christian Brothers had established the year before at 131st Street and Old Broadway. In 1860, Germans of the area established St. Joseph's Roman Catholic Church, which is still in service at the corner of 125th Street and Morningside Avenue.

Eastern European Jews began forming an important presence in the area in the 1880s. Although their population in the area had diminished considerably by the 1950s, the continued activity of Chevra Talmud Torah Anshei Marovi (better known as Old Broadway Synagogue), built in 1923, is among the neighborhood's several remarkable holdouts.

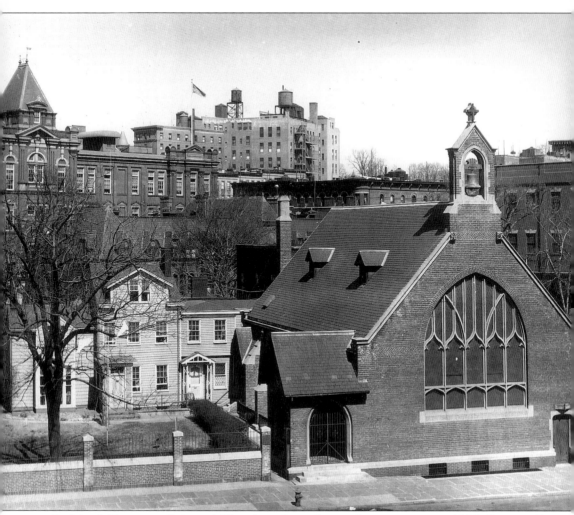

St. Mary's Protestant Episcopal Church and its adjacent frame rectory on 126th Street still evoke their original rural setting. The church was established in 1823 as a mission church of the affluent St. Michael's Episcopal Church in Bloomingdale but was nevertheless made an independent parish. Shown here is St. Mary's second church, a brick structure completed in 1909 by T.E. Blake with the prestigious Carrere & Hastings firm. In 1998, New York City designated the complex of church, parish house, and Sunday school buildings as one landmark. (St. Mary's Protestant Episcopal Church.)

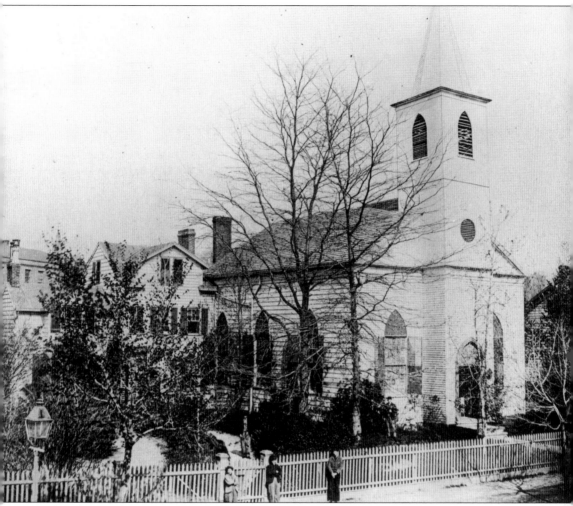

Jacob and Hannah Lawrence Schieffelin donated the land to erect the first St. Mary's building, the same wood-frame church shown here *c.* 1900. The cornerstone was laid in 1824 and the church consecrated in 1826. The congregation included Alexander Hamilton's widow, Elizabeth Schuyler Hamilton, and their children, and it was racially mixed. In 1831, St. Mary's abolished pew rentals, making it the first "free pew" Episcopal church in the city, and possibly in the country. The Schieffelins are buried in their family vault beneath the porch. (Schomburg Center for Research in Black Culture, NYPL.)

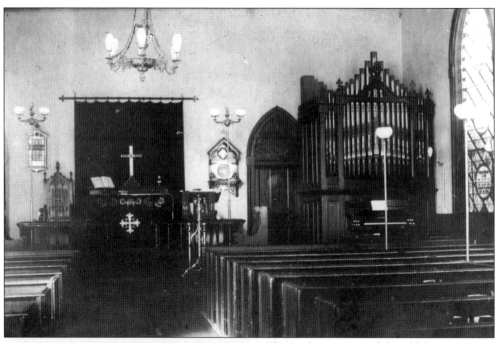

This is the interior of the old St. Mary's in 1908, probably just before it was demolished to make way for the new building. (St. Mary's Protestant Episcopal Church.)

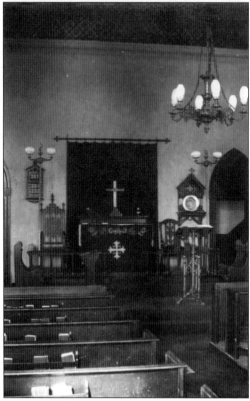

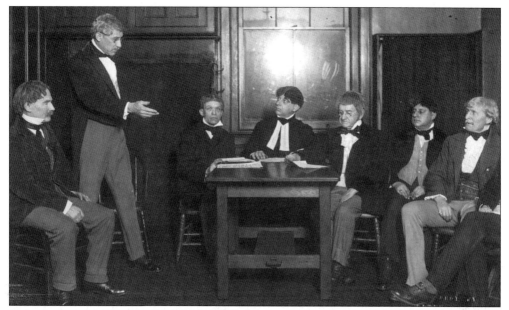

This picture was taken in St. Mary's parish house on February 1, 1923, during the church's centennial celebration. Present members of St. Mary's vestry reenact the first vestry meeting on December 18, 1823. They players are, from left to right, Holton D. Robinson, Carlton Montgomery, John Witherington, Dr. Charles Breck Ackley (rector), Orville Hervey, Darius Palmer, Merton R. Cobb, and the feet of Harry R. Forbes. (St. Mary's Protestant Episcopal Church.)

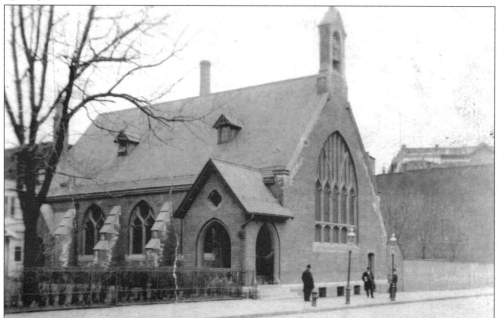

This postcard of the second St. Mary's building probably dates from the first decade of the 20th century. The distant wall to the right of the church is that of the former firehouse, Engine Company 37, now Templo Biblio, a church. (St. Mary's Protestant Episcopal Church; collection of Dorothy Cobb.)

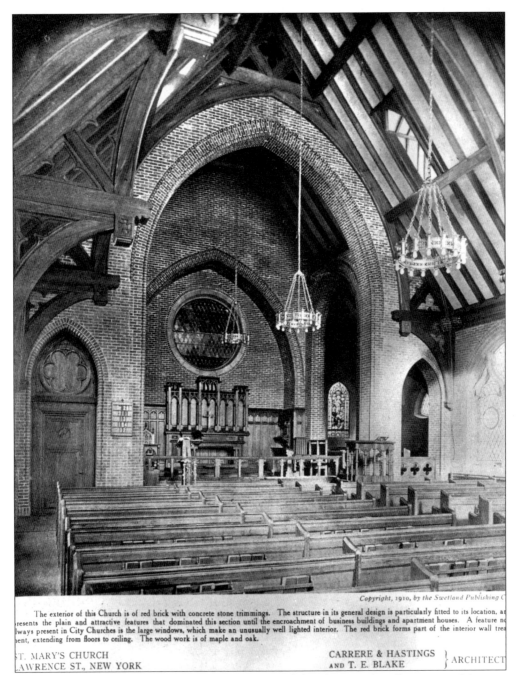

The exterior of this Church is of red brick with concrete stone trimmings. The structure in its general design is particularly fitted to its location, a[s] [p]resents the plain and attractive features that dominated this section until the encroachment of business buildings and apartment houses. A feature n[o] [al]ways present in City Churches is the large windows, which make an unusually well lighted interior. The red brick forms part of the interior wall trea[t] [m]ent, extending from floors to ceiling. The wood work is of maple and oak.

[S]T. MARY'S CHURCH
[L]AWRENCE ST., NEW YORK

CARRERE & HASTINGS }
AND T. E. BLAKE } ARCHITECT[S]

In 1910, *American Architect and Building News* featured this photographic illustration of the new St. Mary's interior. (St. Mary's Protestant Episcopal Church.)

A title for this image might read, "All work and no pray? No problem." For the influx of predominantly Catholic Irish workers building the new Hudson River Railroad, the Christian Brothers established the Church of the Annunciation in 1854. Adjacent to Manhattan College, at 131st Street and Old Broadway, this was the first Catholic church built above Second Street on Manhattan's west side. The Christian Brothers subsequently sold the adjoining church and rectory sites to Archbishop John Hughes. (Church of the Annunciation.)

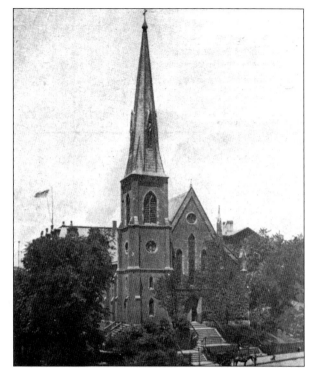

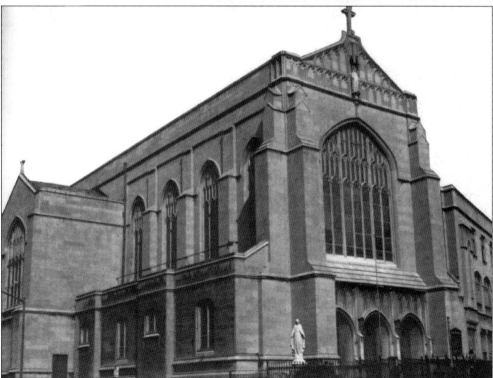

In 1907, the Church of the Annunciation moved two blocks east to its present location at the corner of 131st Street and Convent Avenue. (Church of the Annunciation.)

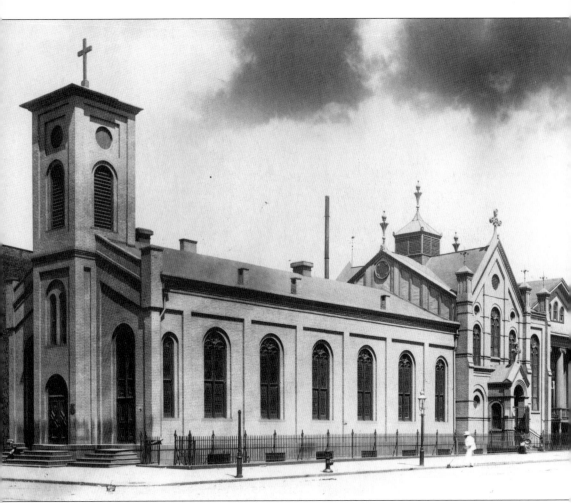

St. Joseph's Roman Catholic Church, at the northwest corner of 125th Street and Morningside Avenue, was founded as St. Joseph of the Holy Family in 1860. Originally serving Manhattanville's German population, the church later reflected the ethnically diverse demography of West Harlem. In 1960, a souvenir history issued for St. Joseph's 100th anniversary noted that "while the construction of the church was going on and the formation of the parish was in progress . . . on May 30, of the year 1861 was celebrated what was probably the first public Corpus Christi procession in New York City. The procession composed of men, women and children started after the appropriate services from the church, wended its way to the grounds of the convent of the Sacred Heart, where customary devotions were held and in excellent order returned to the church." (Schomburg Center for Research in Black Culture, NYPL.)

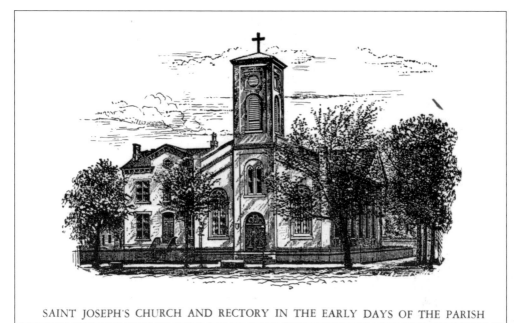

SAINT JOSEPH'S CHURCH AND RECTORY IN THE EARLY DAYS OF THE PARISH

This is St. Joseph's Roman Catholic Church depicted in a 19th-century lithograph. (St. Joseph's Roman Catholic Church.)

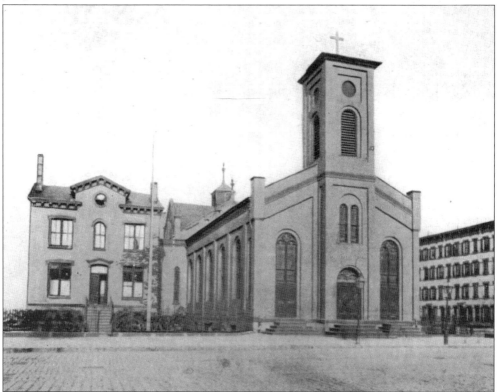

The buildings in the right background of St. Joseph's Roman Catholic Church were built as housing for local brewery workers. (St. Joseph's Roman Catholic Church.)

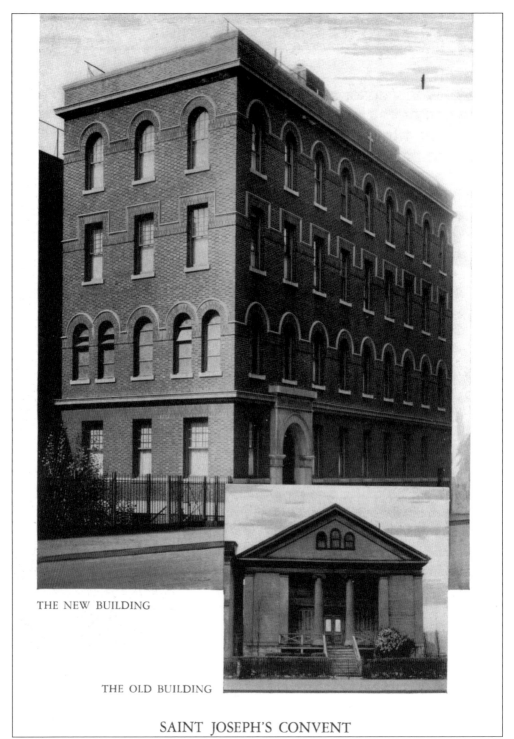

THE NEW BUILDING

THE OLD BUILDING

SAINT JOSEPH'S CONVENT

This picture shows St. Joseph's Convent and a courthouse that was formerly the Manhattanville Methodist Presbytarian Church. (St. Joseph's Roman Catholic Church.)

Old Broadway Synagogue, an Orthodox Jewish *shul* between West 125th and 126th Streets, exudes old-world charm. The synagogue was incorporated in 1911 under the name Chevra Talmud Torah Anshei Marovi, which translates roughly as West Siders' Congregation Torah Teaching Center. The current building was erected in 1923 on what is a rare vestige on Manhattan island of the old Bloomingdale Road. Old Broadway Synagogue has endured to become the last affiliated Jewish synagogue in Harlem, most others having been adapted as Christian churches. In fall of 2001, Old Broadway Synagogue was approved for listing on the State and National Registers of Historic Places. (Municipal Archives.)

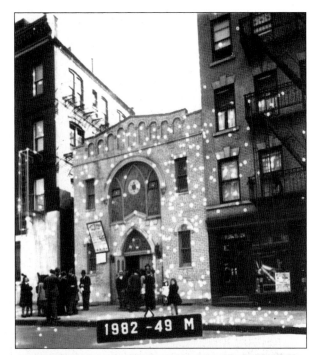

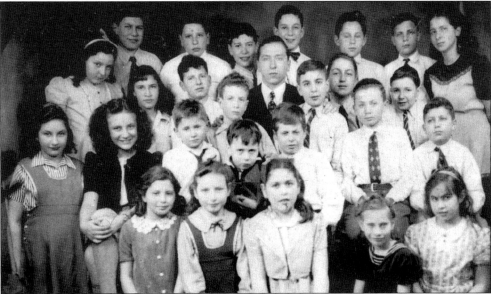

In 1942, the Old Broadway Synagogue's *30th Anniversary Commemorative Journal* featured this picture of Principal Rabbi Shepard Broyde surrounded by children of the Talmud Torah Anshei Marovi. Manhattanville's mostly Ashkenazic Jewish population formed from a great influx of Russian and Polish immigrants to New York during the 1880s. They made initial inroads as peddlers and small shopkeepers and then established more substantial stores and trades along Manhattan and 125th Streets and upper Amsterdam Avenue. By the 1930s, the Jewish population was waning in Central Harlem but remained distinctive for another 20 years in Manhattanville. Under the indefatigable Rabbi Jacob Kret, from 1950 to 1997, Old Broadway Synagogue acquired an unofficial status as the "Manhattanville Jewish Center." (Old Broadway Synagogue.)

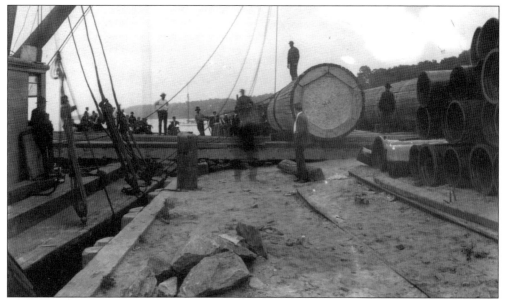

On July 13, 1903, construction of the Cathedral Church of St. John the Divine on Morningside Heights was under way. Much of the building stone passed through Manhattanville first. As seen here, sections of the church's extraordinary columns, quarried in Maine and shipped down the Hudson in barges, were unloaded at the 134th Street wharf. (Cathedral St. John the Divine.)

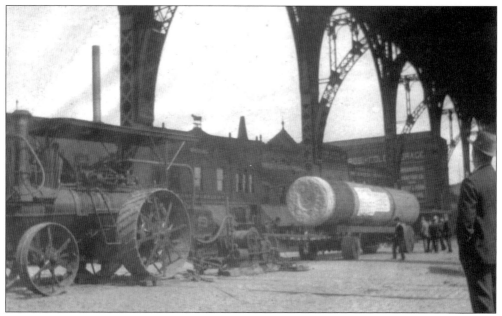

Under the Riverside Drive Viaduct, a solid-wheeled cradle bears a recumbent column section slowly out of the valley. The steam-powered winch (left) prepares to tow the monster down Manhattan Street and up Amsterdam Avenue to the cathedral site. (Cathedral St. John the Divine.)

Five

TIMESAVERS

This little advantage has inspirited our troops prodigiously.

—Gen. George Washington
on the Battle of Harlem Heights
September 16, 1776.

Several episodes of the city's and country's history unfolded in Manhattanville. Some of the most prominent of them involved the Revolutionary War, the War of 1812, and the volatile issue of slavery.

During the Revolutionary War, Manhattanville's valley was known as the Hollow Way, a reference to the area's unique topography. This feature facilitated Gen. George Washington's retreat from British troops on Long Island and helped bring the area to prominence. On September 16, 1776, the general's weary, ragtag American corps induced their enemy to advance into the valley where they successfully repulsed the superior British force. The resultant taste of victory derived from this skirmish, relished by the general, lingered for nearly half a century to inspire James Fenimore Cooper to place this valley in his successful 1821 novel about the Revolution, *The Spy*.

During the War of 1812, the city erected extensive defense fortifications in anticipation of another British attack. At 123rd Street, a barrier gate called the Manhattanville Pass was built across the Bloomingdale Road. Remnants of this defense breastwork—which included the large command post Fort Laight, block houses, and entrenchment lines extending to the Hudson River—remained visible on the neighborhood landscape until well into the 20th century.

New York's system of racial slavery, still legal at this time, was not outlawed until 1827. However, local citizens were agitating overtly and covertly for abolition well before then. In 1817, Quakers from Manhattanville joined others at the opening of the state legislature to decry the continued bondage of African Americans, and Gov. Daniel D. Tompkins delivered his own "special message" in accord. Nevertheless, as fugitives from slavery in the South sought haven in New York through the end of the Civil War, Manhattanville was anything but removed from these chapters in American history.

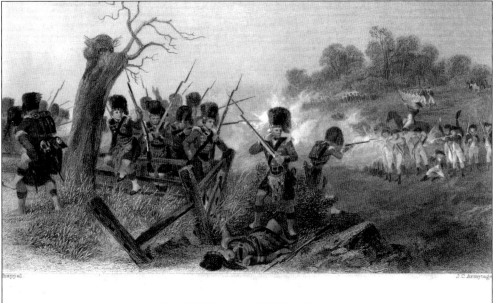

BATTLE OF HARLEM.

On September 16, 1776, the main action of the Battle of Harlem Heights began in Manhattanville's valley, then called the Hollow Way. One of Gen. George Washington's officers, Lt. Col. Thomas Knowlton, was mortally shot, reputedly uttering as he fell, "I do not value my life if we do but get the day." Indeed, the volunteer patriots proved their mettle, driving back the superior British enemy to a bloody climax in a buckwheat field where Barnard College now stands. Three decades later, Manhattanville formed in the valley, steeped in the terrain's Revolutionary War legacy. (Author's collection.)

Point of Rocks, as the outcropping at the southern end of St. Nicholas Park is called, is where Washington directed the battle. He later remarked about the skirmish, "This little advantage has inspired our troops prodigiously." (Author's collection.)

74

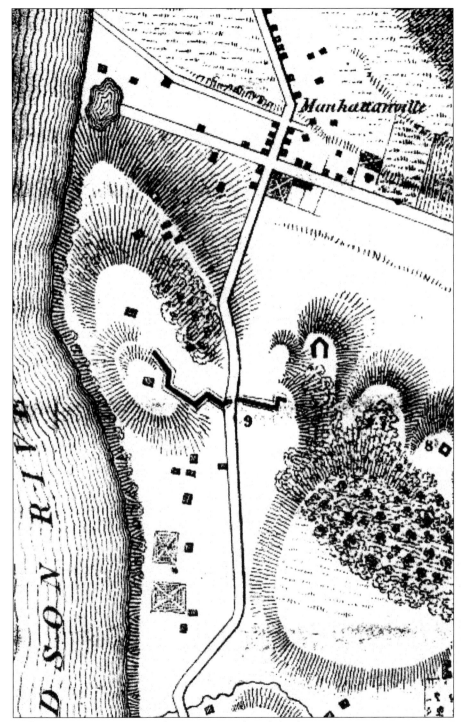

During the War of 1812, New York City prepared to defend its waterways in anticipation of a new attack by the British. A detail from this map of the Harlem Plains and Manhattanville shows placements of upper Manhattan's defense fortifications, which included the Manhattanville Pass barrier gate (indicated by the number 9). (Author's collection.)

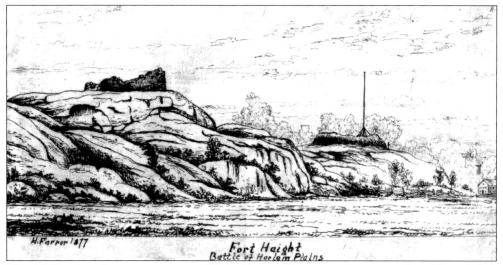

This 1877 etching by prominent artist Henry Farrer offers a rare panorama of two War of 1812 fortifications that were part of the city's uptown defense breastworks called the Manhattanville Pass. A spire extends from the ruins of Fort Laight (mislabeled in the caption), the former command center at Broadway and 124th Street. To the left, the ruins of Blockhouse No. 4 mark Morningside Park's northern end before 123rd Street was cut through across Amsterdam Avenue. The British never attacked New York City, so no shots were ever fired from these posts. Fort Laight today is the site of Morningside Gardens, and Blockhouse No. 4 is the site of Public School No. 36. (Author's collection.)

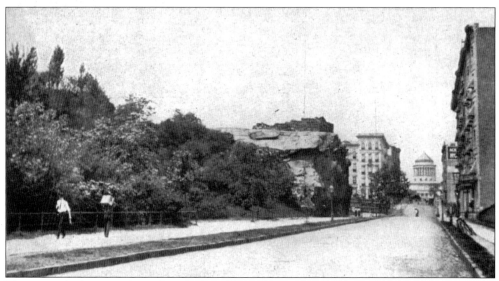

This view looks west from the Harlem Plains along 123rd Street c. 1900. By then, the outcropping carrying Blockhouse No. 4 has been cut through, allowing the street's visual corridor to culminate at the recently erected Grant's Tomb, a site of the Battle of Harlem Heights. (Author's collection.)

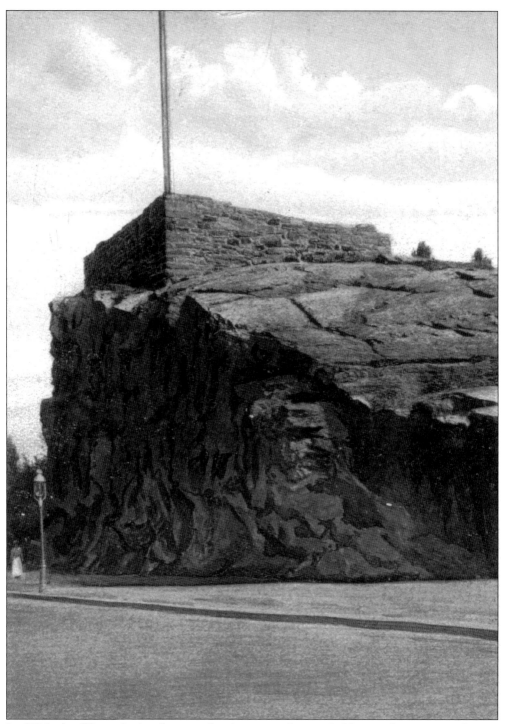

In 1904, the Women's Auxiliary to the American Scenic & Historic Preservation Society placed a tablet atop these rocks commemorating "the remains of a stone tower, a part of a line of fortifications extending from the Hudson to the Harlem River, built for the defense of New York by its patriotic citizens." (Author's collection.)

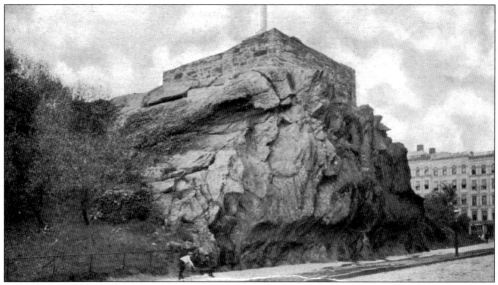

This early-1900s postcard shows the defunct Blockhouse No. 4 from the War of 1812. (Author's collection.)

[Handwritten letter reproduced in facsimile; the transcribed text follows below.]

Some of Manhattanville's Quakers were notable agitators for America's antislavery cause. Following an Albany legislative session in 1817, John Barrow wrote with his wife, Rebecca, to their cousins in England, "Manhattanville 3 Mo. 1817, Dear Cousins S. & S. Emlen. . . . I have lately been absent for a few weeks . . . in Albany, with a memorial from our Meeting for Sufferings in behalf of the poor blacks still held in bondage in the state." The Barrows enclosed Gov. Daniel D. Tompkins's recommendation for a date of emancipation to be set. They hoped the English newspapers might convey that "the Great Britain has done much, yet there is yet much for them to do to wipe away the stain of this abominable traffic in human flesh." (Quaker Collection, Haverford College.)

In Assembly, Jan. 28, 1817.

Message from his Excellency the Governor.

GENTLEMEN,

In my last public communication to the legislature, I had the honor to advert to the present happy condition of our country, and to intimate, that the existing state of society, and the general disposition of mankind, seemed propitious to the promotion of the interests of literature, religion, *freedom* and humanity.

I will now take the liberty of submitting to the legislature, whether the dictates of humanity, the reputation of the state, and a just sense of gratitude to the Almighty for the many favors he has conferred on us as a nation, do not demand that the reproach of slavery be expunged from our statute book.

"No people can be bound to acknowledge and adore the Invisible Hand which "conducts the affairs of men, more than the people of the United States.— "Every step by which they have advanced to the character of an independent "nation, seems to have been distinguished by some token of providential agency."

The same divine munificence which called forth this effusion of gratitude from the Father of his Country, twenty-seven years ago, has been equally, if not more conspicuous, in every subsequent stage of our advancement in prosperity and renown. What more acceptable return can a grateful and enlightened people make to the heavenly Donor of these so great benefits, than by emancipating from bitter servitude, that portion of his creatures which still continue to be held in unjust and cruel bondage, by civilized and independent freemen?

I do, therefore, respectfully, but earnestly, recommend to the legislature, to establish some future day, not more remote than the fourth day of July, 1827, on which slavery shall cease within this state. Before the arrival of that period, most colored persons born previously to the 4th of July, 1799, (and all others are now free by the existing laws,) will have become of very little value to their owners. Indeed, many of them will by that time have become an expensive burden.

To fix a day thus remote for general emancipation, will consequently impair in a very small degree any private right, and will, at the same time, be consistent with the humanity and justice of a free and prosperous people.

DANIEL D. TOMPKINS.

Albany, 28th January, 1817.

In 1799, New York State passed its first act to abolish slavery gradually. By January 1817, however, Gov. Daniel D. Tompkins was pressing the legislature to set an exact date. This broadside reads the governor's recommendation, which was passed into law. Ten years later, blacks throughout New York State would observe July 4, 1827, as Emancipation Day. (Quaker Collection, Haverford College.)

A NORTHERN FREEMAN ENSLAVED BY NORTHERN HANDS.

The abolition of slavery in New York State in 1827 did not ensure safety to African American residents. A decade later, bounty hunters still pursued blacks who were escaping enslavement. They often kidnapped free blacks to sell into southern slavery. The members of one notorious band of these so-called "blackbirders" are portrayed in this woodcut from the *Anti-Slavery Almanac* in 1839. Soon after abducting a Westchester freeman in 1836, Tobias Boudinot, E.K. Waddy, John Lyon, and Daniel D. Nash were identified with a similar errand in Manhattanville. (Boston Society Old State House.)

> GEORGE THOMPSON, a colored man, residing at Manhattanville, in the county of New York, and gardener for a gentleman in that place, was taken from his dwelling at midnight in the latter part of the mouth of March, 1837, under the following circumstances, the same being detailed to the writer, and reduced to writing while Thompson was imprisoned in the Bridewell in ~~~~~ ~~~~~~ ~~~~ ~~~~ gone to bed, and ~~~ ~~~~~~~~ was aroused by a knocking at the door—got up and drew aside the curtain of the window near the door—saw there a colored man—asked him what he wanted—he asked if a man named George Thompson lived here—I said yes—he then wanted to come in, as he was cold—I opened the door to let him in—as

In March 1837, the same four men snatched George Thompson, who is described here as "a colored man, residing at Manhattanville . . . and gardener for a gentleman in that place." The *Colored American* reviewed Thompson's story in 1840, the year when his and similar unfortunate cases had influenced a New York State law entitling all alleged fugitives from slavery to a jury trial. (Columbia University Library.)

When Gen. Ulysses S. Grant died in 1885, an estimated 1 million spectators and 60,000 marchers conducted his funeral procession to this temporary tomb, seen in this official photograph of the Grant Monument Association. Grant lay here under constant guard until his transfer to the landmark mausoleum on April 27, 1897. (Author's collection.)

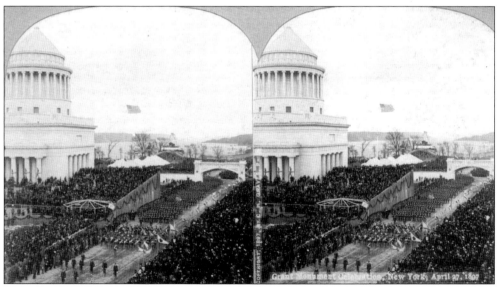

This stereoview shows the April 27, 1897 dedication ceremony of Grant's Tomb, one of the most recognizable symbols of national reverence for a military hero and 18th president of the United States. The monument commands the site that George Washington had recommended a century earlier for the U.S. Capitol. (Author's collection.)

Nearly three decades after the Civil War, its significance was no less poignant. Manhattanville survived unscathed from the terror of the 1863 Draft Riots (the worst campaign of civic unrest in the country's history), but it did inherit the relocation of the destroyed Colored Orphan Asylum. Two unidentified African American men are seen here on April 27, 1892, at the cornerstone-laying ceremony for Grant's Tomb. The city's black community was among the first to donate economic support for the monument. The subscription effort for the monument raised more than $600,000. (Author's collection.)

Six

OCCUPATIONS AND
PREOCCUPATIONS

The people of that ancient locality are distinguished for industry and probity.

—Mayor Fernando Wood, June 30, 1855

As Manhattanville was forming *c*. 1806, tenant farmers and stablemen were working on many of the farms of the area's country gentlemen. Building lots were advertised for sale "principally to tradesmen." Numerous businesses and industries ensued. By 1821, concern over "a valuable manufactory for Woolens . . . number of Grocery Stores and Several Mechanical Branches of Trade" prompted Manhattanville citizens to request that "a Fire Engine be placed in the Centre of said village." In 1839, Daniel Tiemann's paint factory arrived in Manhattanville. It remained the town's principal industrial feature for the rest of the century.

In the 1850s, Manhattanville's wharf bustled with the convergence of a railroad, horse stages, and steamboats and their related industries. Town growth increased construction labor for houses and buildings and major improvements were made to Manhattanville's bulkheads and piers. Even during the financial panic of 1857, Rev. Thomas McClure Peters relieved some of the out-of-work by "employing men to quarry and haul stones for a future St. Mary's, and to macadamize Lawrence Street." Foreigners added substantially to the workforce in the new factories. In the 1880s, D.G. Yuengling Jr.'s model brewery complex employed "a small army of workmen" as coopers, wagon repairers, painters, and blacksmiths.

By 1900, trade, commerce, transportation, construction, and manufacturing were chief occupations. Around the docks, freight barges maintained a constant flow of coal and building stone, and rail freight supplied daily quantities of dressed meat, milk, hay, grain, potatoes, and other farm products. The worsted mill employed about 200 people, and many worked as common laborers, or in general personal service jobs as launderers, waiters, barbers, janitors, and saloon or boardinghouse keepers. Processing industries of brewing, bottling, and iron working employed many people as well.

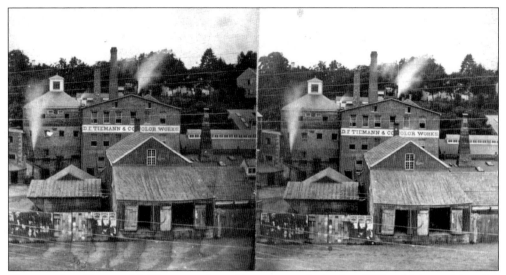

Photographer Herman N. Tiemann shot this stereograph in the 1890s of his uncle's paint factory, D.F. Tiemann & Company Color Works. The factory was the most outstanding commercial feature of industrial Manhattanville for most of the 19th century. The factory was composed of about a dozen buildings on the estate of former mayor Daniel F. Tiemann between Manhattan and West 127th Streets and the Bloomingdale Road and Riverside Drive. (Author's collection.)

This is Julius William Tiemann, Daniel's brother, who was a managing partner of the D.F. Tiemann & Company Color Works. His son, Herman Newall Tiemann, was a well-known New York photographer, who took this shot of his father in front of his downtown photograph shop. (David L. Tiemann.)

ARGE FIRE IN MANHATTANVILLE

TIEMANN'S PAINT FACTORY DESTROYED.

At 1:30 o'clock this morning a fire broke ou [the] extensive paint works of D. F. Ti[e]mann & Co., situated at the foot of We[st] [O]ne Hundred and Twenty-ninth-street, North Rive[r]. [Th]e building in which the fire originated is [a th]ree-story brick structure, and, despite the exe[rti]ons of the firemen, the flames spread wit[h gr]eat rapidity, owing to the inflammable nature [of th]e materials in the factory throughout the e[ntir]e structure. The flames extended to a thr[ee-st]ory brick building, and a three-story fram[e b]uilding adjoining the factory, which a[re al]so owned by the firm. The firem[en ar]e endeavoring to save from destructi[on a] row of frame buildings opposite the factory, b[ut w]ith small prospect of success. The fire, at 2 A. M[. is] at its height, and the loss will probably rea[ch $]50,000.

This story of a fire at the Tiemann's Manhattanville paint factory on September 17, 1879, ran in the *New York Times*. The factory was rebuilt, as it had been when an earlier fire destroyed it in 1840. But a curious and somewhat fortuitous accident occurred in 1860. After a factory hand threw some liquid green paint on a flower bed of white anemones, it was reported that "the flowers have since made their appearance with petals as green as grass." The mishap was said to have important horticultural promise. (NYPL.)

GRAPHITE.—THE HERON MINING COMPANY, owners of the best and the largest known Graphite Mines, (those in Wake County, North Carolina,) have their Graphite, for Founders and for Lustre, prepared in the best manner, and also made into paint by their agents in New York, Messrs. **D. F. TIEMANN & CO.,** No. 45 Fulton street. After long experience, the Heron Mining Company, with the best Graphite, and prepared as none others know how, are now supplying the market through their agents above named, who are in possession of the most ample testimonials of the superiority of this paint over all others. 32 4tc.

This classified advertisement ran in *Scientific American* on April 16, 1859, under listings "Important to Inventors."

D. F. TIEMANN & CO.

ESTABLISHED 1807.

D. F. TIEMANN. J. W. TIEMANN. P. C. TIEMANN.

W. F. TIEMANN. D. F. TIEMANN, JR.

MANHATTANVILLE

PAINT & COLOR WORKS.

EUREKA

FACTORIES,

MANHATTANVILLE, NEW YORK.

DEPOT,

16 MURRAY STREET & 19 PARK PLACE, N. Y.

P. O. BOX 2382.

JOHN P. PRALL, PRINTER BY STEAM, 9 SPRUCE ST., N. Y.

A variety of materials went into the manufacture of D.F. Tiemann & Company's premium paint colors. They included oak bark from Virginia for brown and yellow, logwood from the West Indies for black and brown, and lima wood from South America for maroon and others. A single word on the back fold of Tiemann's sophisticated product catalog in 1884 reads, "Confidential." (David L. Tiemann.)

The 10-story Broadway Storage Warehouse at Broadway and 130th Street was described in 1910 as "one of the most modern and up-to-date storage warehouses in New York City." The brick-and-steel building's steam-heated rooms were considered an ideal innovation for piano storage, and its high-tech safe deposit vaults were burglarproof and fireproof. The building is still a prominent storage warehouse today. The small building in the foreground is also still active, although no longer as Flynn's Saloon. Today it serves as a Pentecostal church. (John Heliker.)

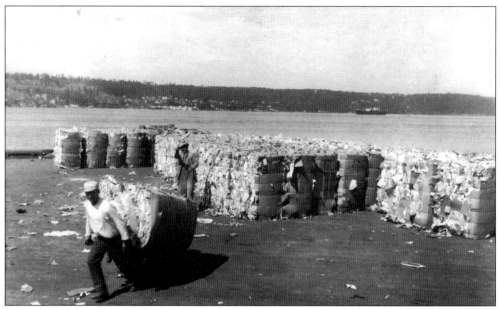

A caption on the back of this undated photograph reads, "New York is a literary town judging by the daily mass of printed matter that reaches the city dumps." The men at work on the Hudson River dock at 134th Street are salvaging paper, probably *c.* 1930. Turning the city's waste into profit, paper was baled here and shipped west to be recycled by paper manufacturers. (Author's collection.)

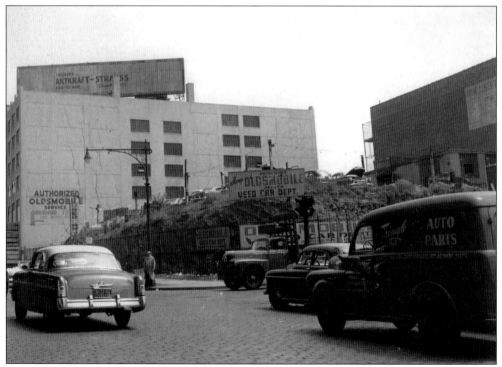

This photograph shows a used-car dealership on the site vacated by Manhattan College. (Author's collection.)

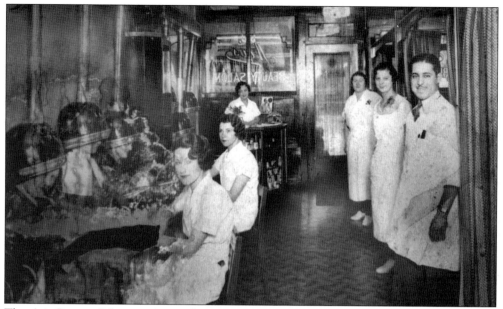

The Aris Beauty Salon on Amsterdam Avenue at 121st Street is only a few feet away from where Aristedes Demetriou opened his original shop in 1933, when he posed for this picture. A permanent hairstyle does not stand the test of time better than the proprietor does. Now more than 90 years old, Mr. Aris, as everyone knows him, is still presiding over local heads. (Aristedes Demetriou.)

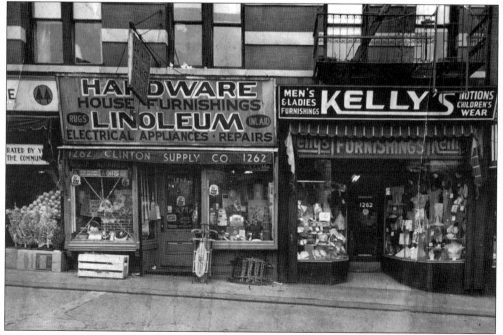

Clinton's Hardware, on the southwest corner of Amsterdam Avenue and 122nd Street, has been a neighborhood fixture for half a century. Proprietor Ray Clinton's father opened the shop on the northern corner c. 1950. He keeps this photograph of the original storefront on display. (Ray Clinton.)

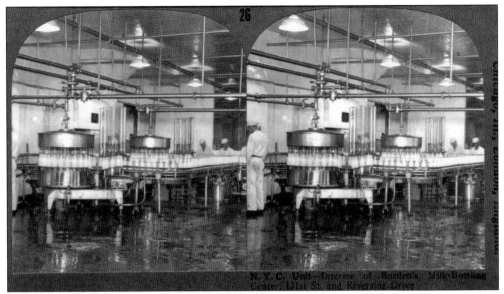

This stereoview looks inside the New York City Unit of Borden's milk-bottling plant at 131st Street and Riverside Drive. Several neighborhood buildings still recall a bustling dairy-processing industry that included Sheffield Farms and McDermott-Bunger. Some facilities had sections reserved for public observation of the bottling process. (Author's collection.)

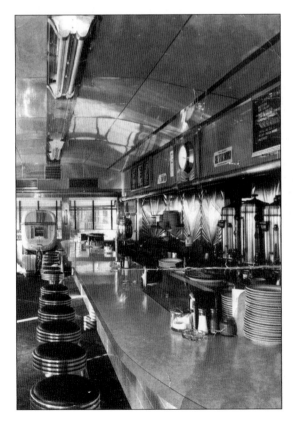

The West Market Diner at 659 West 131st Street, in the shadow of the Riverside Drive Viaduct (over 12th Avenue), is said to be the only diner built by the Mountain View Diner Company still operating in Manhattan. Members of the 1950s counterculture of this old establishment enjoyed the comforts of a jukebox. (Bill Lolis.)

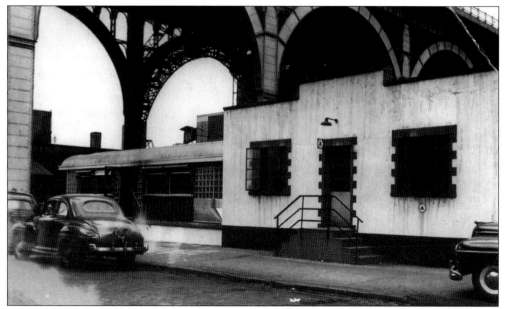

Two cars make up the West Market Diner. The rear car is the kitchen, constructed by the "diner-a-day" company of P.J. Tierney & Sons and placed on the lot in 1921. Four years earlier, the company's patriarch, known as the inventor of the modern diner, died from indigestion after a meal in one. The front car, made by the Mountain View Diner Company, came in 1948. Local meat-packing, dairy, and brewery industries once supplied the predominant clientele, which still draws from the neighborhood's working community. (Bill Lolis.)

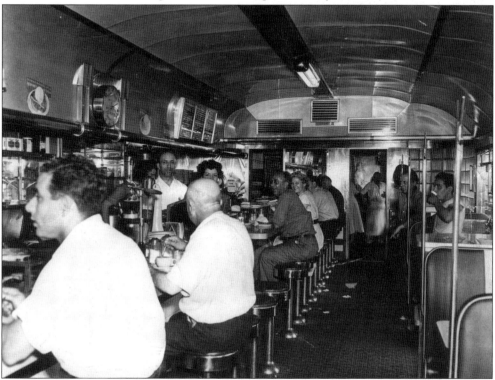

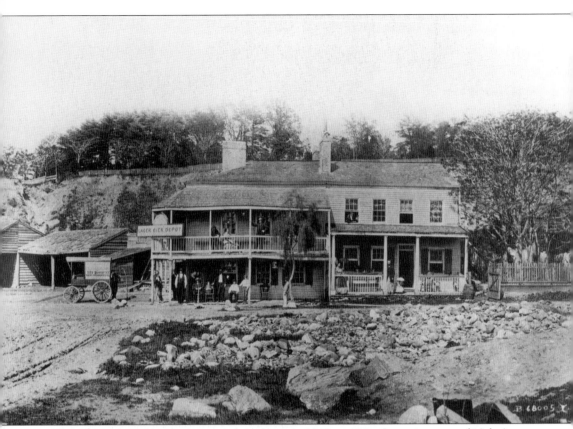

This photograph shows a tavern and residence c. 1862 on 131st Street just east of 12th Avenue. Both were owned by Mrs. Parker, who commissioned the picture and is in the second-story window of the house on the right. The wagon beside the Lager Bier Depot advertises Peter Kohlbeck's photographic services at 229 Bowery Street for "Views, Residences &c." It was probably on hand by necessity to develop the wet plates immediately after he shot the picture. (Schomburg Center for Research in Black Culture, NYPL.)

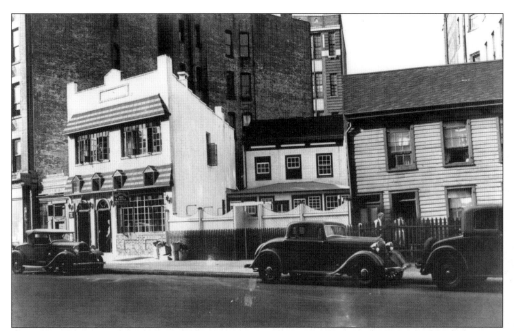

This 1934 photograph by Percy Loomis Sperr shows the Old Homestead Bar & Grill, on 126th Street (formerly Lawrence Street). In the early 1900s, this industrial pocket of the town—abundant with brewery, bakery, and factory workers—had several saloons, poolrooms, and restaurants. The former eatery has since become a popular art gallery. (NYPL.)

Adjacent to the Old Homestead was this two-story frame house, seen without stucco in 1932. The bohemian quaintness of such vernacular houses as this (many built before the Civil War) was the case in point of an article in 1921, when the *Haarlem Villager* advocated the conversion of old Manhattanville into a "latin quarter" for artists and writers. So, this house's current use, minus the picket fence, with an art gallery next door is a little ironic. (NYPL.)

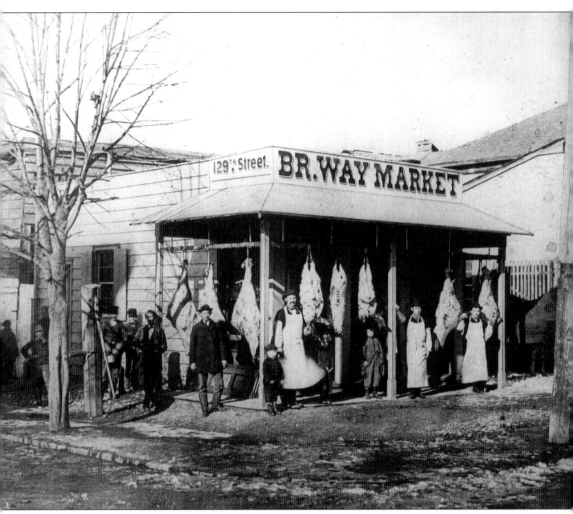

The Broadway Market, pictured c. the 1890s, was a butcher shop once located at 129th Street and Old Broadway. If its close proximity to the village pump would give one pause today, it made this a center of activities in Manhattanville then. The slaughterhouse was just down the street. Joe Churchill, a well-known butcher here years earlier, had also operated the stage line to this point from 32nd Street. Associated with Boss Tweed's ring, Churchill successfully sued for $48,000 of public money for losses incurred when Broadway was being improved. On the right, the leading horses of the stage are leaving from the stable behind the shop. (New-York Historical Society.)

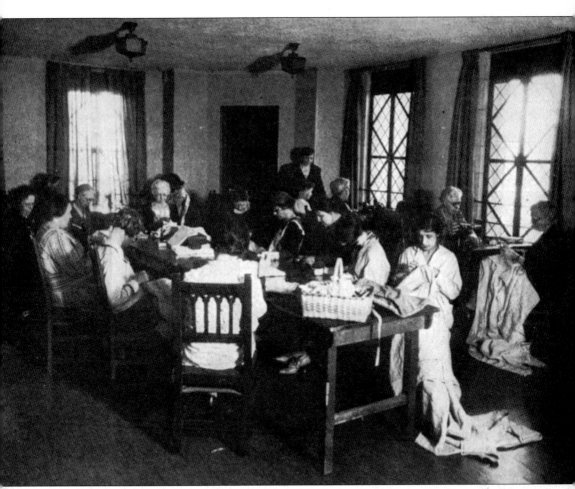

Women work in the sewing room in 1931 on the 16th floor of Riverside Church's tower. The program was part of a co-operative plan with the state labor bureau to secure jobs for out-of-work residents in the Manhattanville area. A volunteer staff directed the room at this particular project and its equipment of electric machines and cutting tables. About 40 women worked four days a week, earning wages from their piecework. (Author's collection.)

This undated picture shows Manhattanville's first post office. From 1851 to 1861, it functioned out of postmaster James Doyle's grocery, flour, and feed store at the southeast corner of Old Broadway and 129th Street. By 1920, when the Prohibition amendment had outlawed the alcohol trade in the United States, the basement of this grocery, it is rumored, was a speakeasy. (NYPL.)

Seven

LOCATION IS EVERYTHING

Claremont . . . suggests in a rather humble way what these mansions were,
and in a very magnificent way what their outlooks were.

—Mrs. Schuyler Van Rensselaer, *Century*, May 1897

Manhattanville's streetscapes recall a town shaped by the post–Civil War industrial revolution. Yet before the progress of 20th-century development, it was also renowned for some of the most picturesque homesteads in New York.

In the years following the Revolutionary War, the city's wealthy merchants commonly built country retreats in upper Manhattan. A partial motivation was to distance themselves from the yellow fever epidemics in summertime. Scourges visited the city almost annually in the late 18th and early 19th centuries. But for those who could afford houses overlooking the Hudson River, the exquisite views were not insignificant.

Distinguished homesteads within or nearby Manhattanville in its first decade included those of Jacob Schieffelin, Alexander Hamilton, Thomas Buckley, Michael Hogan, and John B. Lawrence. Other notable estates followed, belonging to Daniel Tiemann, Terence Donnelly, Daniel Devlin, and Oswald Ottendorfer. Estates and institutional grounds were fated to be apportioned into building lots. In a nostalgic story, H.C. Bunner observed that "those twin demons of encroachment, Taxes and Assessments, had definitively won in their battle with both the farmers and the country-house gentry." The ultimate blow to many of these properties would be the cutting through of city streets on which apartment houses would regiment the landscape.

Despite the great changes that resulted from rapid transit, the streetscapes retain a considerable number of anomalies that hold keys to the area's past.

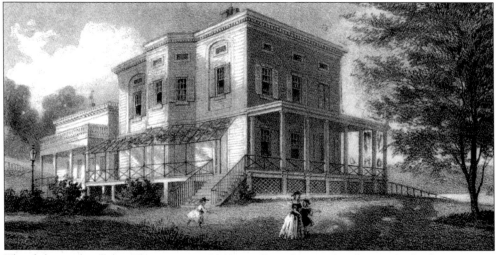

This lithograph of the Claremont *c.* 1860 recalls a famous specimen of suburban country mansions that once fronted Manhattan's riversides above Washington Square. The house predated the 1776 Battle of Harlem Heights fought nearby, but its fabled cachet swelled most after sea captain Michael Hogan bought the property in 1806. Joseph Bonaparte, Napoleon's older brother, spent some of his exile here as the deposed king of Spain. The architect George B. Post was born in 1837, when diarist and former New York mayor Philip Hone wrote of "Mr. Post's place, at Manhattanville, which belonged once to Lord Courtney." He added, "It is one of the finest places on the Island." (Author's collection.)

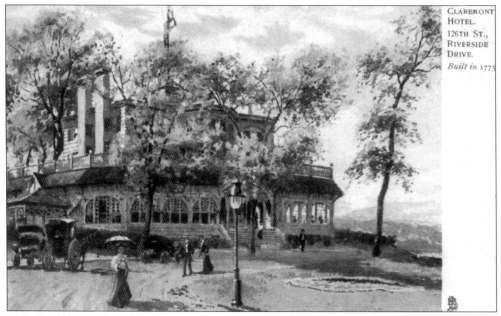

This English Tuck "oilette" postcard paints an idyllic picture of the Claremont Hotel. Notwithstanding extravagant alterations, the Claremont was one of the last of Manhattanville's great houses when a mysterious fire burned it to the ground in March 1951. (Author's collection.)

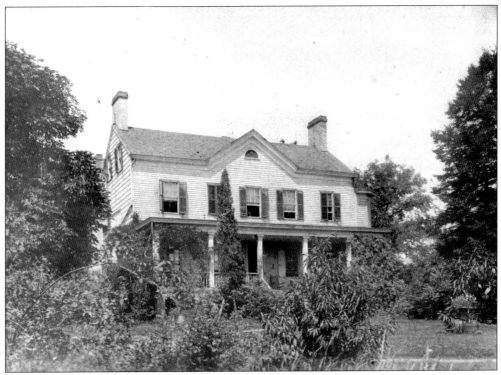

Daniel F. Tiemann resided in this house in Manhattanville. (David L. Tiemann.)

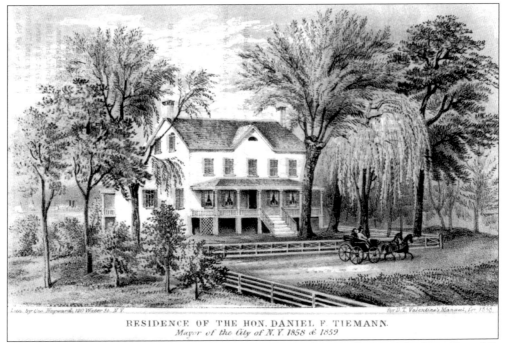

RESIDENCE OF THE HON. DANIEL F. TIEMANN.
Mayor of the City of N.Y. 1858 & 1859

This was the home of the city's mayor when this lithograph, "Residence of the Hon. Daniel F. Tiemann," was drawn for the 1858 *Manual of the Corporation of the City of New York.* (Author's collection.)

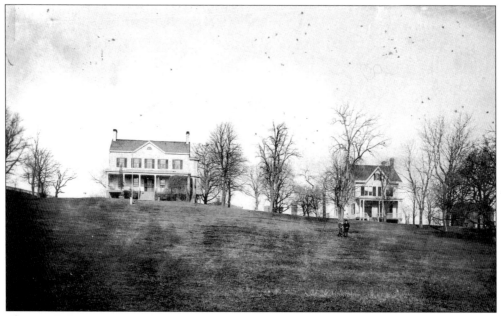

This c. 1890s view shows the houses of Hon. Daniel F. Tiemann and his son Peter Cooper Tiemann, on the crest of the hill at West 127th Street (today's Tiemann Place). (David L. Tiemann.)

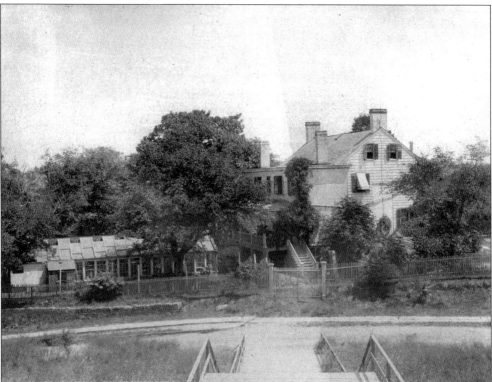

Daniel Tiemann's house, located just east of Riverside Park, is shown on August 18, 1891. (David L. Tiemann.)

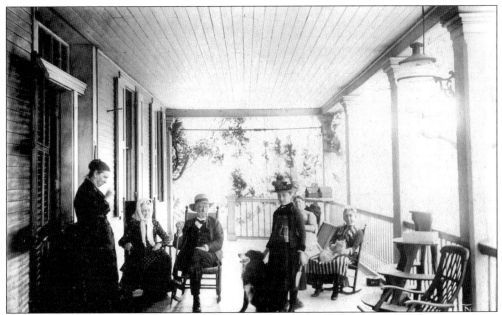

Members of Daniel F. Tiemann's family relax on the front porch on August 18, 1891. (David L. Tiemann.)

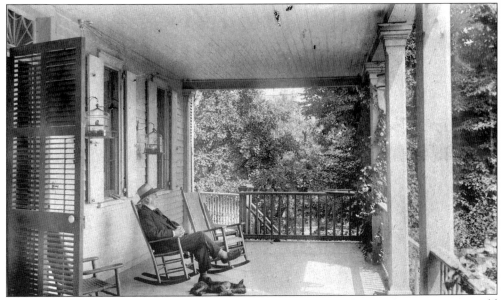

Sounding more awed than wistful at time's passing, former mayor Daniel F. Tiemann would soon recall, "In 1832 I bought from Thomas Buckley my country seat, which I made my home for so many years, and I little dreamed the opening of new streets would drive me out of it as it has done." (David L. Tiemann.)

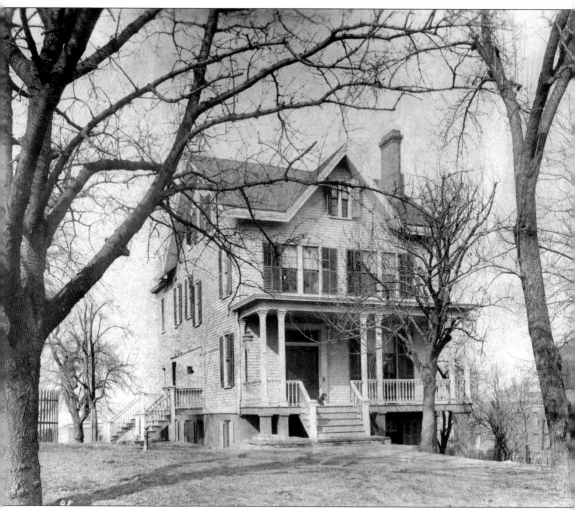

Peter Cooper Tiemann, the son of the former mayor, lived in this house on 127th Street. The house is shown here c. 1895, the year after his death. In 1888, when the Episcopal diocese was proposing to establish a new parish in Manhattanville, it fell to him as clerk of the vestry of St. Mary's to voice the objection. Peter Tiemann wrote to Bishop Henry Codman Potter that they were "opposed to the holding of any public services by any clergyman of the Church, temporarily or otherwise, within the limits of what they claim as the Parish . . . the district bounded Northerly by 135th Street, Easterly by the 8th Avenue, southerly by 121st Street and westerly by the Hudson River." Peter Tiemann's house was torn down in 1906. (David L. Tiemann.)

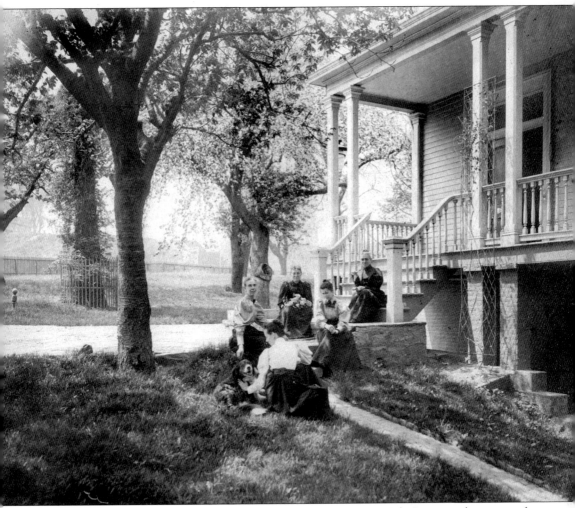

These ladies are at the steps of Peter Tiemann's house on West 127th Street in the spring of 1895. Possibly taken as a memento before the family moved, the picture reflects the area's rural surroundings that were soon to vanish. (David L. Tiemann.)

A 1938 bulletin of the Museum of the City of New York described the acquisition of the above canvas. Victor Gifford Audubon, son of the famous naturalist John James Audubon (portrayed seated upon a rock), chose John B. Lawrence's riverfront property for his "View of the Hudson River at Manhattanville, c. 1845." This locale, wrote curator Grace Mayer, was "chosen all too infrequently by the artists of the period." She added, "Manhattanville of the mid-nineteenth century possessed a rural charm enhanced by the grandeur of the Hudson, with its great natural backdrop of the Palisades." Within a decade, however, the lines of bulkheads and the Hudson River Railroad tracks were regimenting this bucolic landscape. In the early 1900s, Thaddeus Wilkerson's photo postcard below, "Hudson River, north from 134th Street," located the same waterfront brimming with river craft and wharf structures that include Free Bath No. 9 (foreground), a floating municipal public bath. (Author's collection.)

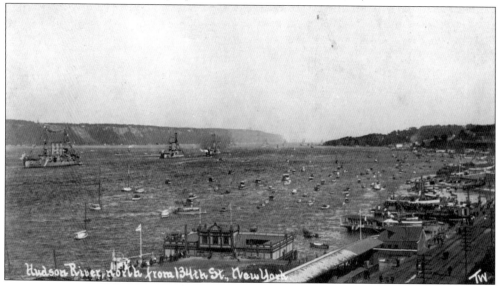

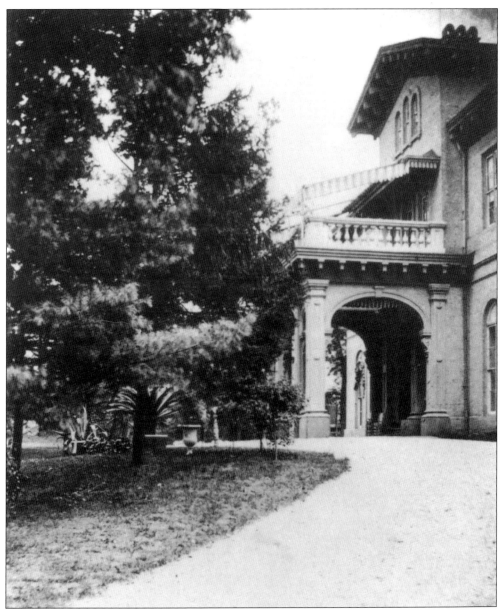

"My Dear Doctor— I knew that you would be pleased to get the Donnelly House. . . . It takes a lot of time to gather these pictures. . . . I wonder if you have any objection to 'swapping' pictures with me and thus saving time for each of us." —John J. Hopper, February 21, 1921.

Grovemount, a sumptuous mansion built by Terence Donnelly *c.* 1845, later passed to his brother Edward C. Donnelly, a former tax commissioner and officer of the Emigrant Savings Bank. The heavily forested estate stretched from 133rd to 136th Streets between 10th Avenue and the Bloomingdale Road. A chapel fitted into the house's top floor drew neighbors for mass. By 1900, nine years after Donnelly's death, development cut the house's surrounding woods to the quick as 134th, 135th, and 136th Streets were dug out the next year. (Schomburg Center for Research in Black Culture, NYPL.)

St. Helena, St. Monica, St. Frances, St. Elizabeth, St. Augusta, and the flagship building St. Agnes, shown here at 41 Convent Avenue, are the six apartment buildings that make up the full-block Covent Gardens complex. When the Female Academy of the Sacred Heart sold this adjoining property for building development in 1905, deed covenants explicitly prohibited African Americans from occupancy. The New York State Supreme Court overturned those racial restrictions in 1941. In recent years, a tenant management team from the population that was originally banned has won public praise for bringing about the revival and historic restoration of St. Agnes. Below is the lobby of 41 Convent Avenue. (Andrew Alpern.)

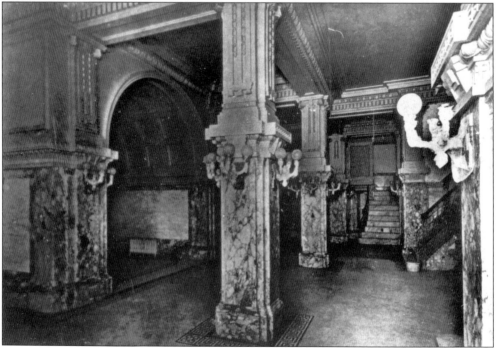

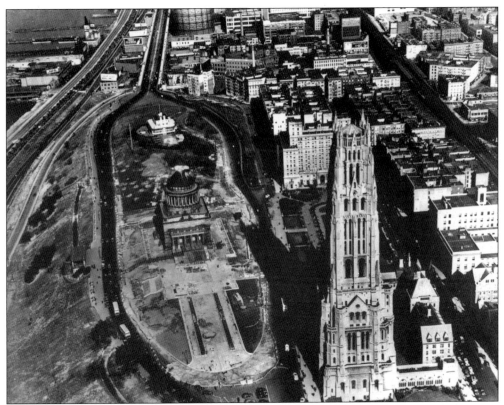

This aerial view looks north over Claremont Hill at the densely built-up Manhattanville area *c.* 1932. (National Park Service.)

Herman Tiemann, who photographed most of the Tiemann estate in the 1890s, is seen with a boy in a cart. Peter Tiemann's house appears in the background. (David L. Tiemann.)

This *c.* 1814 painting entitled "Looking North Towards Bloomingdale Heights" shows the mansion built by John B. Lawrence *c.* 1810. The mansion overlooked the Hudson River west of Broadway above 134th Street. An ancestral John Lawrence from Long Island was one of New York's original patentees and twice mayor of the city, in 1673 and 1691; he also acted as a disinterested neighbor in 1712 for the partitioning of the Harlem Common Lands but was not one of the beneficiaries. (Author's collection.)

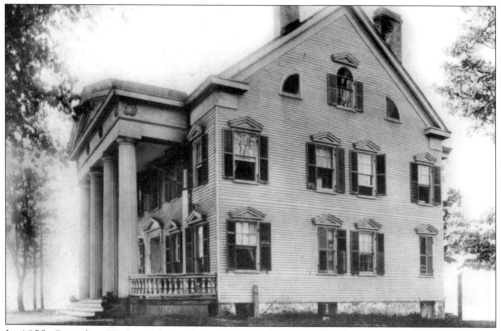

In 1855, Cornelius W. Lawrence, who in 1834 had become the first New York mayor elected by the people, lived in the Lawrence mansion as it looks here with his wife, children, sister, and a multiracial and multinational household staff. H.C. Bunner, a writer and editor of *Puck*, remembered the place as "one of those good old American houses where the men-children are born with politics in their veins—that is, with an inherited sense of citizenship, and a conscious pride in bearing their share in the civic burden." (Schomburg Center for Research in Black Culture, NYPL.)

"The only colored family, Nichols, on the old Road, lived in a little cottage just east of Broadway on the north side of 130th St." —John J. Hopper.

This house on Lawrence Street is reminiscent of the Nichols house nearby. The modesty of cottages such as this was often underestimated. An 1855 census cited Peter Nichols Jr., an oysterman, as the head of household. His frame house had even greater significance than its assessed value of $1,600 for, since 1821, an amended New York law required that African American males fulfill a $250 property qualification and three years state residency in order to vote. Both Peter and his father, Peter Nichols Sr., were known as activists for black male suffrage and as abolitionists, having been appointed in 1838 by the New York Association for the Political Elevation and Improvement of the People of Color as representatives for the 12th Ward. (Author's collection.)

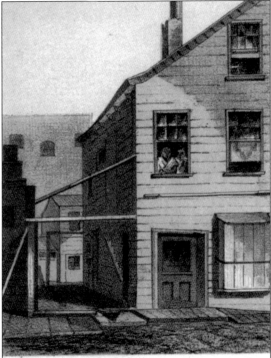

ITH. OF MAJOR & KNAPP. 449 BROADWAY, N.Y.

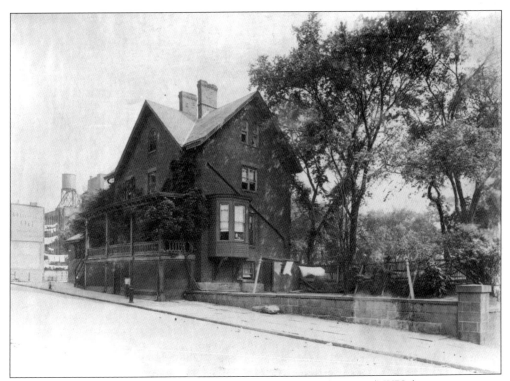

This substantial brick house stood on Old Broadway at 133rd Street. (NYPL.)

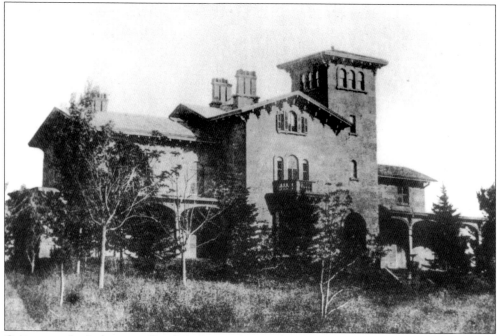

Craigmoor, the Italianate villa of clothier and city chamberlain Daniel Devlin, stood at 138th Street between Broadway and 10th Avenue. Devlin's estate gave way in the 1880s to the equally impressive Hebrew Orphan Asylum. (Schomburg Center for Research in Black Culture, NYPL.)

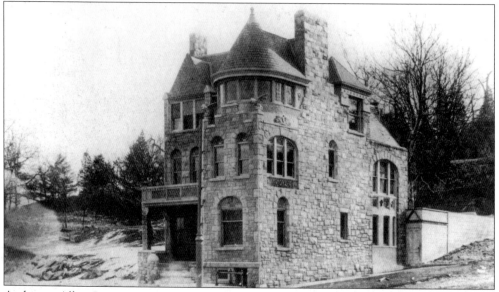

Architect Allen Bates Jennings built this house at the northeast corner of 136th Street and Broadway, where he lived from 1887 to 1904. The rough-faced granite house stood out from its rural surroundings until Broadway subway excavation in 1900 ushered in a wave of apartment buildings. Broadway playwright Paul Armstrong lived here in 1905. Two years later, the house became a restaurant. It survived the 1920s bootleg era as a Prohibition speakeasy but was torn down in 1930 with the onset of the Great Depression. (Schomburg Center for Research in Black Culture, NYPL.)

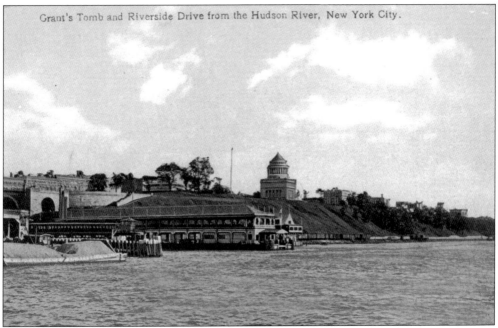

Grant's Tomb and Riverside Drive from the Hudson River, New York City.

This early-1900s postcard features Grant's Tomb and Riverside Drive as seen from the Hudson River. They overlook the freight tracks of the New York Central & Hudson River Railroad line and the 129th Street recreation pier. (Author's collection.)

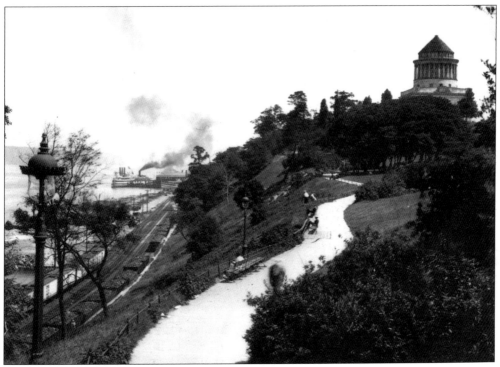

This path leading to Grant's Tomb through Riverside Park is today the wooded Bird Sanctuary. Beyond can be seen the steamboat docks at Manhattanville. (National Park Service.)

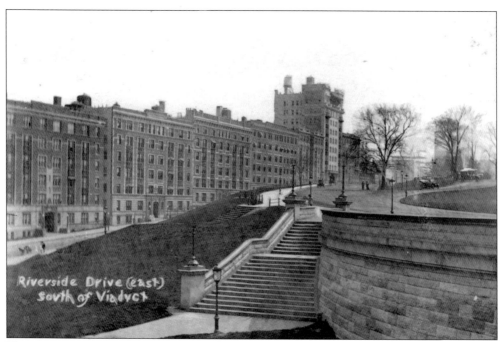

This *c.* 1910 image shows Riverside Drive south of the viaduct at present-day Tiemann Place. (Author's collection.)

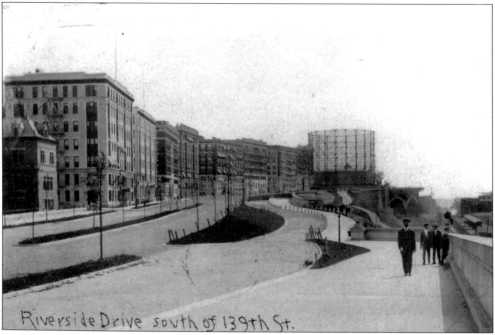

Looking south along Riverside Drive from 139th Street, this *c.* 1910 view shows an industrial drum of the Consolidated Gas Company. The behemoth towered over the viaduct at 132nd Street. (Author's collection.)

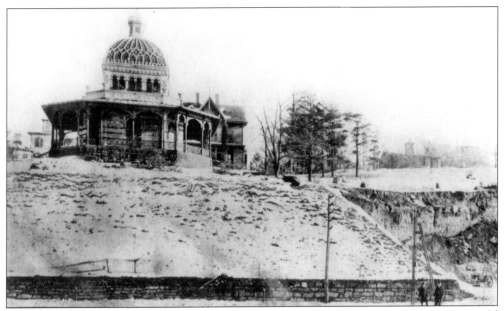

This Moorish pagoda stood at the foot of West 135th Street on the estate of Oswald Ottendorfer, German newspaper publisher of the *New Yorker Staats Zeitung*. Designed in 1879 by William Schikel, it was an architectural confection made of terra cotta and red brick with a cupola. A veranda encircling three sides overlooked the Hudson River. The pagoda was used for informal receptions and as a summer house. When a fire in 1888 destroyed much of the Convent of the Sacred Heart, the nuns temporarily used the Ottendorfer mansion and grounds and used the pagoda as a chapel. By 1904, this riverbank landmark lay directly in the path of the extension of Riverside Drive, and attempts by local citizens to preserve and restore it were in vain. (Schomburg Center for Research in Black Culture, NYPL.)

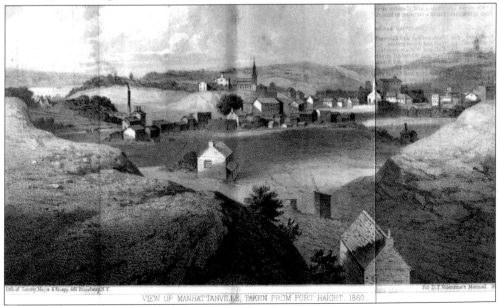

Entitled "View of Manhattanville taken from Fort Haight," this image dates from 1860. (Author's collection.)

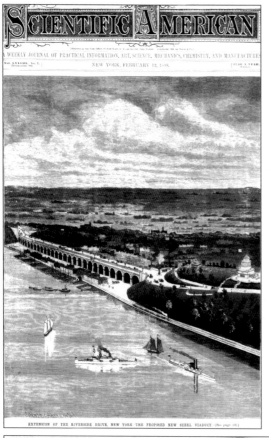

This 1898 *Scientific American* cover shows the "Proposed New Steel Viaduct" for the Manhattanville valley. (Author's collection.)

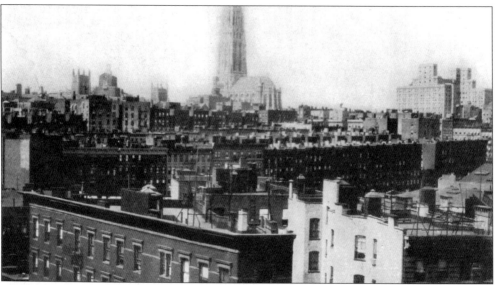

The June 1931 monthly bulletin from the new Riverside Church showed this streetscape of Manhattanville. Its Charity Organization Society designated this as a large portion of the "Riverside district," where it hoped to secure employment for out-of-work residents during the Great Depression. (Author's collection.)

114

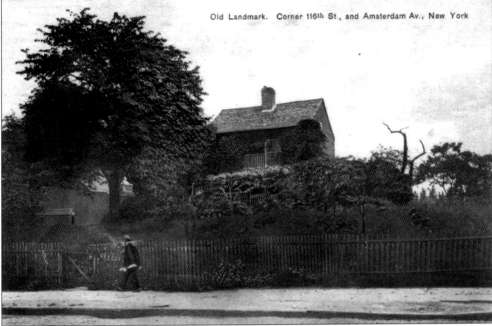

Old Landmark. Corner 116th St., and Amsterdam Av., New York

Almost defiantly, some rustic landmarks of earlier days dotted the Manhattanville landscape in light of the encroaching development of Morningside Heights. Both of these postcards published by Charles Friedgen, a local druggist, use photographs probably taken *c.* 1897. The frame house above, at Amsterdam Avenue and 116th Street, seems to be at the present location of the Columbia University law school. The house to the right may have been edged out by Friedgen's own drugstore, the address of which was also given as Amsterdam Avenue and 120th Street. (Author's collection.)

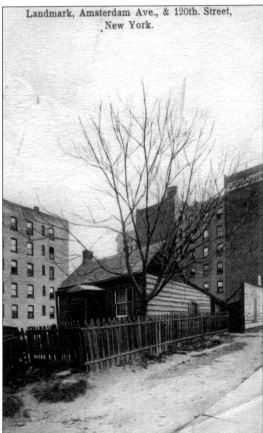

Landmark, Amsterdam Ave., & 120th. Street, New York.

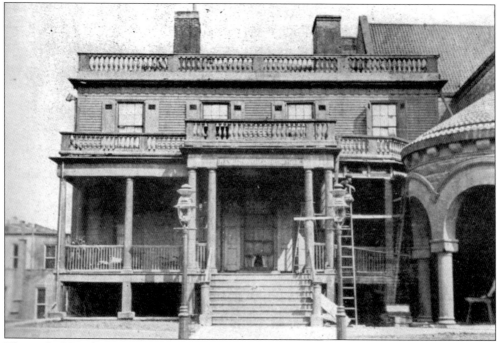

This is the Hamilton Grange, which was the home of Alexander Hamilton in 1858, according to the *Atlantic Monthly*. It served as "his country seat, near Manhattanville" before the duel in which he was fatally shot by Aaron Burr. Hamilton's widow and children were prominent pew holders at St. Mary's Protestant Episcopal Church. (Author's collection.)

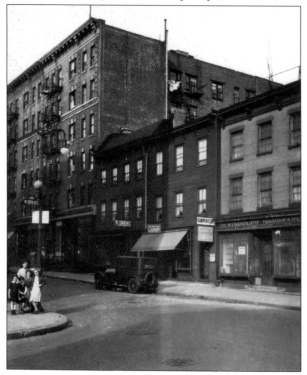

A photographer captured this view of the corner of Old Broadway and 129th Street in 1932. (St. Mary's Protestant Episcopal Church.)

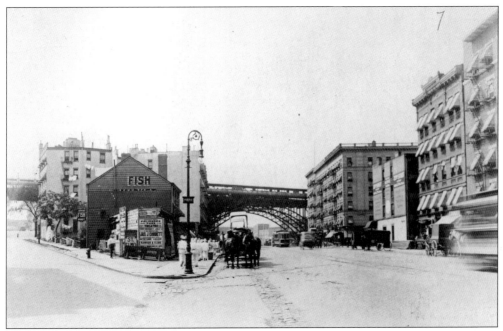

This 1920 view looks west down 125th Street (the name having just been changed from Manhattan Street), past the fork formed by the convergence of Tiemann Place (formerly 127th Street). (NYPL.)

A newspaper advertisement *c*. 1909 described the new Whitestone at 609 West 127th Street (now 45 Tiemann Place) as "one of the richest ornaments to a neighborhood full of fine, high-class apartment houses." Designed by Emery Roth, the building had a colorfully detailed facade, which still intrigues passersby with its terra-cotta leaves, berries, geometric shapes, and lions. The entrance lampposts were possibly a tribute to the displaced "mayor's lamps" that had marked Daniel F. Tiemann's driveway. (Andrew Alpern.)

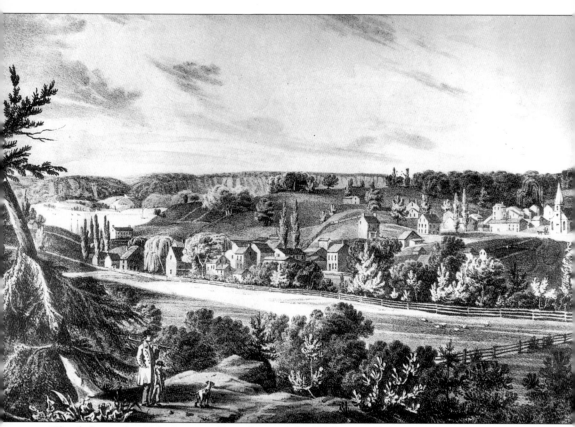

This lithograph of Manhattanville is from a John William Hill drawing, published by George Endicott. The time of the scene is 1834. The perspective looks northeast across the valley, when Manhattanville's rural terrain was still innocent of urban encroachment. The village was laid out along Manhattan Street, then much lower than the grade of Lawrence Street, where St. Mary's Church sits to the right. Manhattan Street also sits atop a major geological fault. The two streets conformed to the area's topography before the Commissioner's Plan of 1811 imposed the grid pattern. The streets were renamed 125th and 126th Streets, respectively, after 1920. Today, they still perpetuate Manhattanville's original diagonal street pattern, connected by Old Broadway, a vestige of Manhattan's famous Bloomingdale Road. (St. Mary's Protestant Episcopal Church.)

Eight

COMFORTS AND ROUTINES

I drove about the upper part of the town in my rockaway,
and paid fugitive visits to Manhattanville . . .

—Herman Melville, "Bartleby the Scrivener."

Inasmuch as Manhattanville's natural picturesqueness was legendary, its social landscape was equally compelling to many civic-, philanthropic-, or reform-minded visitors. In its early developmental years, Manhattanville was pursued as a place of resort and retreat. In 1807, the *Public Advocate* commented that "this flourishing little town, pleasantly situated near the banks of the Hudson, about eight miles from the City Hall, to the eye of the . . . tourist, appears well worthy of observation."

Colorfully illustrating the Hudson shorelines from New York to Albany in 1846, master engraver William Wade acknowledged Manhattanville's conduciveness to visitation and socializing by the village's "having a convenient landing and wharf, and containing about 80 houses, with five hundred inhabitants."

In 1853, W.H. Graham's *Strangers Guide Around New York & Vicinity* recommended a "fast horse" up Third Avenue to Yorkville, Harlem, and across to Manhattanville. That same year, a character in Herman Melville's famous short story "Bartleby the Scrivener" took refuge in this suburb. Also, the fabled Claremont mansion, now under the proprietorship of Edmund Jones as a roadhouse, was enjoying new favor from the cream of New York's fashionable society. Manhattanville was deemed a worthy getaway.

As America celebrated its centennial in 1876, a feature in *Scribner's* magazine mused that for many, "the most interesting side of New York will be, not in the congeries of brown-stone houses and marble stores, but in the poorer and quainter districts," which, it added, "deserve as much attention as Broadway or Fifth Avenue."

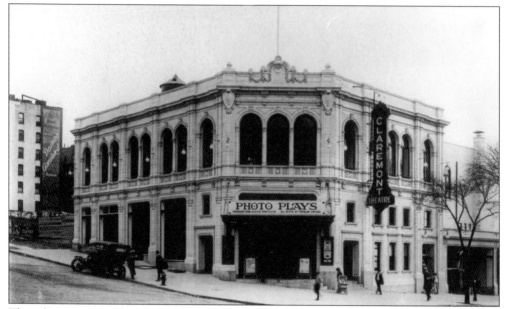

This photograph may have been taken when the Claremont Theatre opened in 1914. The entrance bills Oscar Apfel's *The Last Volunteer,* a silent World War I movie of that year; the next year, Thomas A. Edison screened his *On the Stroke of Twelve.* The three-story, Italian Renaissance–style theater was designed by Gaetan Ajello, and its white terra-cotta facade still commands the southeast corner of Broadway and 135th Street. The building's multiple uses have included a dance hall, automobile showroom, roller-skating rink, and retail store. But to remind passersby that this was one of the city's earliest movie theaters, a curious bas-relief of a movie camera adorns the cornice below the banner. (Museum of the City of New York, Wurts Brothers Collection.)

The outdoor amphitheater Lewisohn Stadium—donated by the philanthropist Adolph Lewisohn to City College and located at Amsterdam Avenue between 138th and 140th Streets—was at the northern rim of Manhattanville. It was the setting of legendary concerts for decades, including the debut of George Gershwin's "Rhapsody in Blue," and recitals by Paul Robeson and Marion Anderson. (Author's collection.)

120

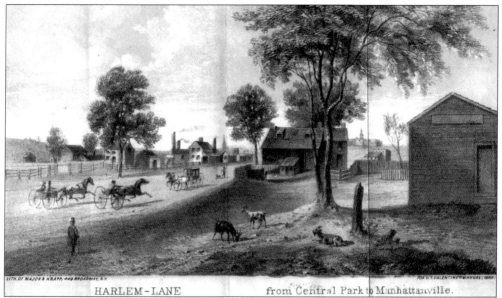

HARLEM-LANE from Central Park to Manhattanville.

This Major & Knapp lithograph appeared in David T. Valentine's *Manual of the Corporation of the City of New York* for 1865. It portrays the famous "Harlem-Lane from Central Park to Manhattanville," which extended roughly from the park to 145th Street along present-day St. Nicholas Avenue. This was a favorite post–Civil War rendezvous for gentlemen riders to race their fast trotters. It might be said that railroad mogul Commodore Vanderbilt and *New York Ledger* owner Robert Bonner (known as the "owner of the world's fleetest horses") were the "quality" of life in this fast lane. Their double-team rivalries reputedly sparked "the first real friction between . . . two prominent riders" and spurred the expansion of the racehorse-breeding industry. (Author's collection.)

Bertholf's Hotel was one of the celebrated clubhouses on Harlem Lane. (Author's collection.)

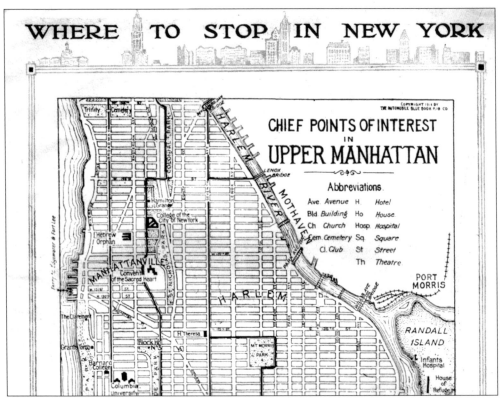

This tourist map for upper Manhattan dates from 1914. (Author's collection.)

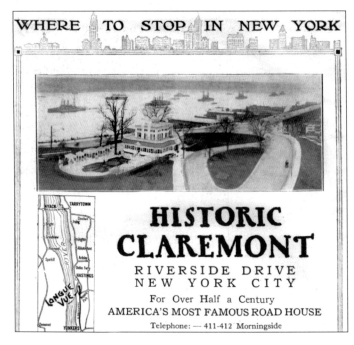

Judging from the pageant of battleships in the river, the photograph in this 1914 Historic Claremont Inn advertisement was from the Henry Hudson–Robert Fulton commemoration in 1909. (Author's collection.)

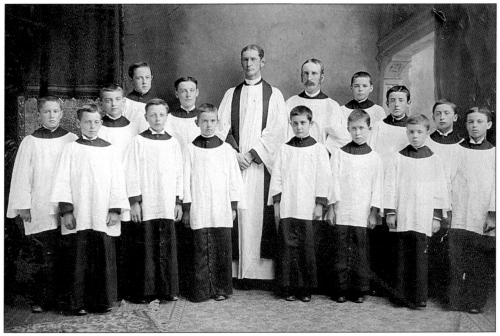

St. Mary's rector Rev. H.R. Hulse campaigned strenuously for the new church, built in 1908. (St. Mary's Protestant Episcopal Church.)

Acolytes of St. Mary's are standing outside the rectory, probably in the 1920s, with Rev. Charles Breck Ackley to the right. (St. Mary's Protestant Episcopal Church.)

This picture, probably from the 1920s, shows members of St. Mary's Order of the Fleur de Lis, a girls' church club that started in Massachusetts. "Three things we pledge: Purity within ourselves; Loyalty to our Church; Service to others." The Fleur de Lis—who also believed in camping trips, hiking, entertainments, and educational classes—are shown here expressing their *joie de vivre*. (St. Mary's Protestant Episcopal Church.)

This young couple is shown tying the knot as Mr. and Mrs. Santiago Rivera in 1946. Rev. Charles Breck Ackley of St. Mary's presides. (St. Mary's Protestant Episcopal Church.)

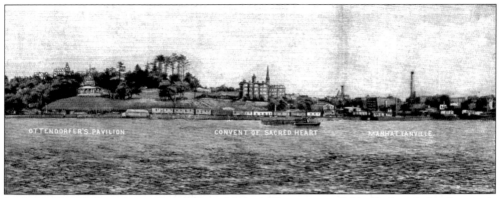

In 1888, the Hudson River Day Line published "Panorama of the Hudson," the first such photographic look at any river. The work documented the 150-mile visual excursion along both shorelines of the Hudson, from New York Harbor to Albany. (Author's collection.)

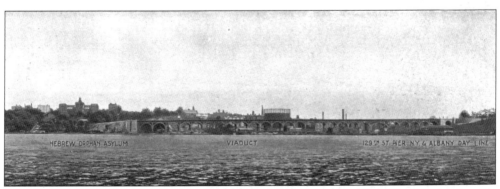

The Hudson River Day Line's "Panorama" revisited the river in 1904. The Manhattanville waterfront was still compelling, albeit radically changed. (Author's collection.)

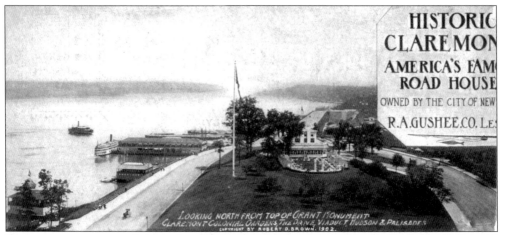

This is a souvenir card from the "Historic Claremont America's Famous Road House." (Author's collection.)

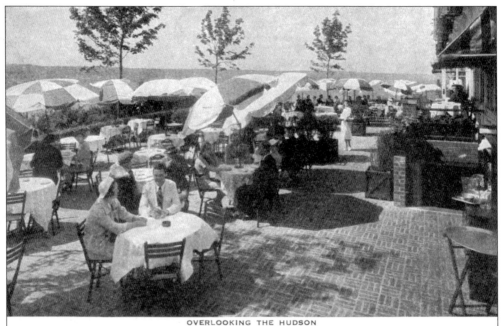

The Claremont Inn and Gardens overlook the Hudson River c. the 1940s. (Author's collection.)

This is the 1948 graduating class of St. Joseph's Roman Catholic School on Convent Avenue. (St. Joseph's Roman Catholic Church.)

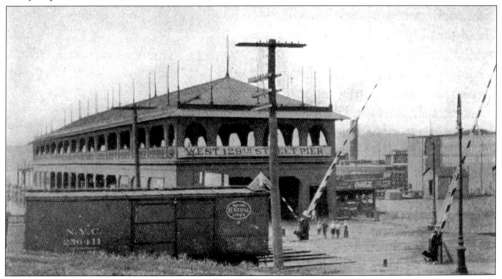

This is one of several recreation piers erected around the city's shorelines in the 1890s, all of which have since vanished. They were constructed by the Department of Plant and Structures but belonged to the Dock Department and were administered by the Park Department, mostly for passive recreation. Covered but open, the breezy piers were cherished especially by adults for dancing, classes, or listening to band concerts. The piers were once considered an important part of the park playground system. (Author's collection.)

BIBLIOGRAPHY

Biographical Sketches: Hon. Daniel F. Tiemann, Mayor of the City of New York. United States Democratic Review, New Series, Vol. XLII, New York: Conrad Swackhamer, 1858.

Bliven, Bruce, Jr. *Battle for Manhattan.* New York: Henry Holt and Company, 1956.

Bunner, Henry Cuyler. "Tiemann's to Tubby Hook." *Scribner's* magazine, Vol. XIV, New York: Charles Scribner's Sons, 1893.

Cannon, John. *St. Mary's Manhattanville: A Study of the Changing Parish*, unpublished thesis. New York: Union Theological Seminary, 1959.

Devlin, William. "Shrewd Irishmen: Irish Entrepreneurs and Artisans in New York's Clothing Industry, 1830–1880." *The New York Irish*, Baltimore: The Johns Hopkins University Press, 1995.

Guernsey, R.S. *New York City and Vicinity during the War of 1812–'15.* New York: Charles L. Woodward, 1895.

Haffner, Gerald O., ed. *Virginia Magazine of History and Biography*, "A British Prisoner of War in the American Revolution, the Experiences of Jacob Schieffelin from Vincennes to Williamsburg, 1779–1780."

Hopper, John J. *The Manhattanville Free School*, unpublished manuscript, 1921.

Jackson, Kenneth T., ed., *The Encyclopedia of New York City.* New Haven, Connecticut: Yale University Press and New York Historical Publishing, 1995.

Jennings, E. Allen. *Manhattanville: An Architectural Retrospect.* 1940.

King, Moses. *King's Handbook of New York City 1892.* Boston: Moses King, 1892.

King, Moses. *Notable New Yorkers of 1896–1899.* New York. 1899.

Peters, John Punnett, DD, ed. *Annals of St. Michael's Protestant Episcopal Church, New York.* New York: G.P. Putnam's Sons, 1907.

Pierce, Carl Horton. *New Harlem Past and Present: The Story of an Amazing Civic Wrong, Now at Last to be Righted.* New York: New Harlem Publishing Company, 1903.

Riker, James. *Revised History of Harlem: Its Origins and Early Annals.* New York: New Harlem Publishing Company, 1904.

Singer, Ruth. *Historical, Social and Economic Changes of Manhattanville.* New York: Manhattanville Community Outreach–St. Mary's Church, 1973.

Speyer, Emilie W. *An Adventure in Community Cooperation: Manhattanville Neighborhood Center.* New York. 1954.

Stokes, I.N. Phelps. *Iconography of Manhattan Island.* New York: Philip Dodd, 1918.

Styles, Michael Hogan. *Captain Hogan: Sailor, Merchant and Diplomat on Six Continents*, unpublished manuscript. 2000.

Ulmann, Albert. *A Landmark History of New York.* New York: D. Appleton-Century Company, 1939.

Valentine, David T. *Manual of the Corporation of the City of New York.* Various years.

Woolsten, Howard Brown. *A Study of the Population of Manhattanville.* New York: Columbia University Press, 1909.